C000039847

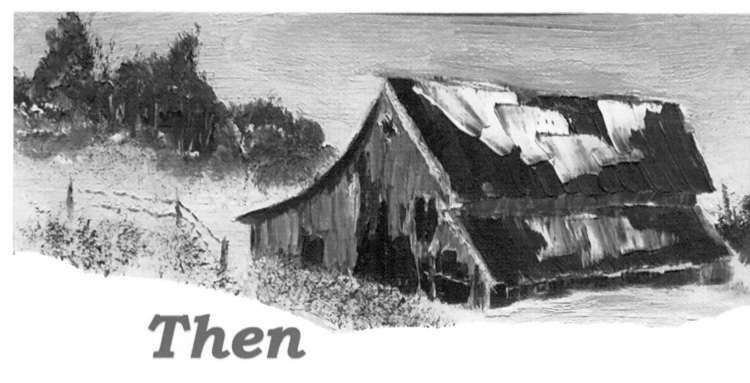

Then
We Were Poor
A Story in Photographs

Melissa Menzone

THEN WE WERE POOR – A STORY IN PHOTOGRAPHS

Copyright © 2021 Melissa Menzone. All rights reserved.

Cover artwork by Joseph Menzone

No part of this book may be used or reproduced in any manner whatsoever without written permission, except in the case of brief quotations embodied in critical articles and reviews. For more information, e-mail all inquiries to info@silverpencilpress.com.

Published by Silver Pencil Press, Charlton, MA.

Printed in the United States of America
ISBN-13: 978-1-951016-32-6
Library of Congress Control Number: 2021905783

For Oakley, Aria, and Josselin in hopes that they each realize that being rich has nothing to do with money and everything to do with family.

Table of Contents

Us and Beyond

Preface

Although I have prepared and written this remembrance of our family's heritage, my family runs through different trees altogether. For the first 40+ years of my life, I believed I was of Polish descent on my paternal grandfather's side. Shockingly, my father discovered in 2013, while cleaning out my recently deceased grandmother's home, that in fact his father, my grandfather, had come from Russia! Today, I ask myself: "Why didn't Grandpa ever correct us when we said 'Polish'?" Surely, he must have had some story to share about his family's home country?

As for my paternal heritage, all I have is this one letter, a first communion photo of Irene Ladyko (unknown date), and a few events on an ancestorial timeline. I have found internet photos of Galimchyna, which today is located in Belarus, a rural town similar to 1907 Canaan, Vermont.

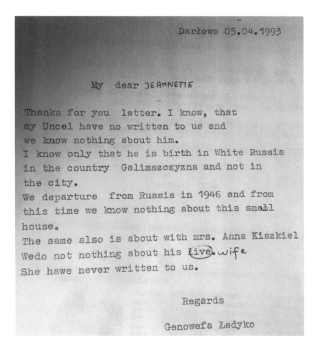

There won't be any surprise nationalities revealed in this remembrance. This pictorial representation of the Menzone family spans seven generations which are predominantly Canadian French joining with a line of Italian; then, a bit of Irish enters into the mix late into the 20th century.

As for the title of this book, that comes from another piece of my history as well:

> I was cleaning the closet, packing my father's things when I found my mother's diary. It was in French, but I recognized it. As I flipped through the foreign pages, I found a single entry written in English. I can never forget it: "Now we are poor."
>
> Rachel (Joyal) Ladyka

That diary, found around 1973, is lost now. My maternal grandmother might have been referring to the Great Depression, World War II, or the Flood of 1955 when the water had risen

past the 2nd floor of the Joyal family's home in West Thompson, Connecticut; my mother, then 9, had to climb onto the roof with the rest of the family to wait for rescue. In any event, I was born in 1968 and my maternal grandmother died in 1969, so I never knew her. I would have liked to have read her diary, to understand why she felt so poor.

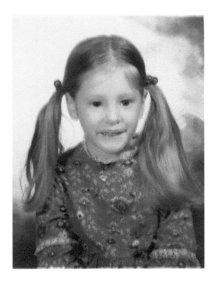

Each and every one of our family's ancestors worked hard, whether they were farmers, millworkers, or seamstresses, housewives, pipefitters, or policemen, waitresses, accountants, or postal clerks, to support our families, enduring and growing strong from the efforts. We had family, love, and laughter. We learned perseverance, optimism, and dedication. We have integrity and pride. We showed respect and were respected in return. If that's what it means to be poor, *Then We Were Poor*.

After Dad (Joseph Menzone) passed away in 2012, it was too much for Mom (Evelyn Elliott Menzone) to be alone. Helping her move resulted in a treasure chest full of unorganized photos. Eventually, I scanned almost 2,500 photos onto the computer and many others remain in a box labeled "unknown." Some family members are missing, which is unfortunate and, although some of our cousins are occasionally shown in family shots, those family branches have not been explored in any great detail here. Some photos are in poor quality but provide an image for relatives that otherwise wouldn't be available; none of the photos have been doctored.

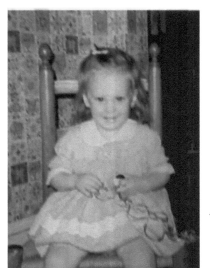

The anecdotes come from clippings, notes, and conversations over the years – I did my best to preserve them as they had been told to me. As of the writing of this book, only Mom (85yo) and Aunt Edie (Edith Elliott Baronousky) (83yo) remain of our elders and I am grateful for their recollections.

I hope by reading this family history you are encouraged to enjoy your own family, to remember and respect those that came before you, and to realize the importance of the wealth of love.

Melissa Menzone

(top) Author, January 1973
(bottom) Author, November 1969

Laflamme – Morin

Family

(circa 1877 – 1960)

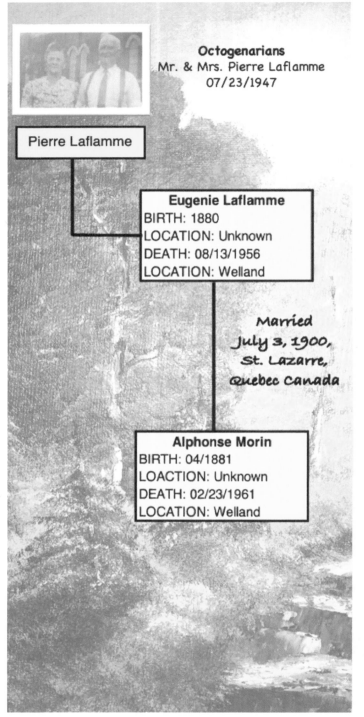

Octogenarians
Mr. & Mrs. Pierre Laflamme
07/23/1947

Pierre Laflamme

Eugenie Laflamme
BIRTH: 1880
LOCATION: Unknown
DEATH: 08/13/1956
LOCATION: Welland

Married
July 3, 1900,
St. Lazarre,
Quebec Canada

Alphonse Morin
BIRTH: 04/1881
LOACTION: Unknown
DEATH: 02/23/1961
LOCATION: Welland

Eugenie's mother's name is unknown. It is presumed that they are in their 80s at the time of this 1947 photo. Eugenie had at least one brother, Peter Laflamme, who attended their 50th wedding anniversary.

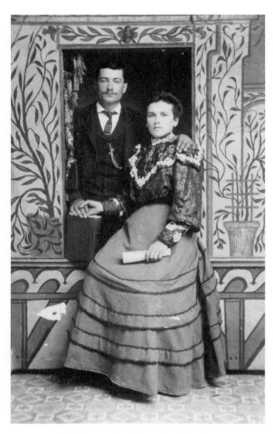

Alphonse & Eugenie Morin
1900

Alphonse had at least one brother, Theophile Morin, Nothing is known about his parents.

4

1918
Marie Morin

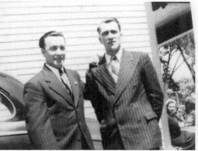

08/13/1946
Alphonse & Alphee

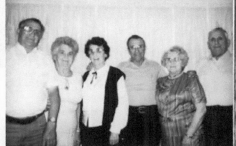

06/23/1984
Alphonse - Alice - Marie -
Alphee - Eugenie - Clovis

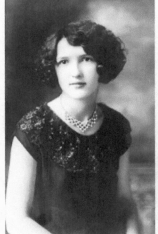

1927
Aurelia

1941
Aurelia &
Alphonse

1919
Marie

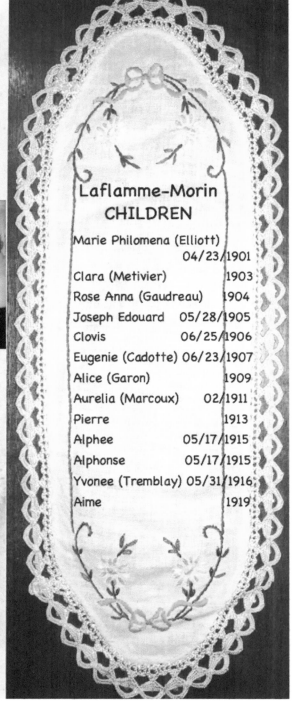

Laflamme-Morin
CHILDREN

Marie Philomena (Elliott)
04/23/1901
Clara (Metivier) 1903
Rose Anna (Gaudreau) 1904
Joseph Edouard 05/28/1905
Clovis 06/25/1906
Eugenie (Cadotte) 06/23/1907
Alice (Garon) 1909
Aurelia (Marcoux) 02/1911
Pierre 1913
Alphee 05/17/1915
Alphonse 05/17/1915
Yvonee (Tremblay) 05/31/1916
Aime 1919

5

1923
Joseph

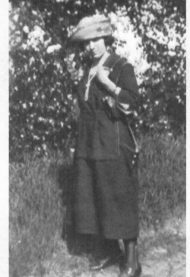

1920
Marie

1941
Eugenie - Alphonse - Marie

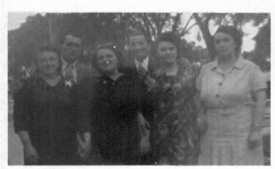

1950s
Rose Anna- Alphonse - Eugenie -
Alphee - Alice - Marie

05/1992
Marie - Clovis - Alice

6

1921
Marie

1926
Alice

1919
Clara

1921
Clara & Marie

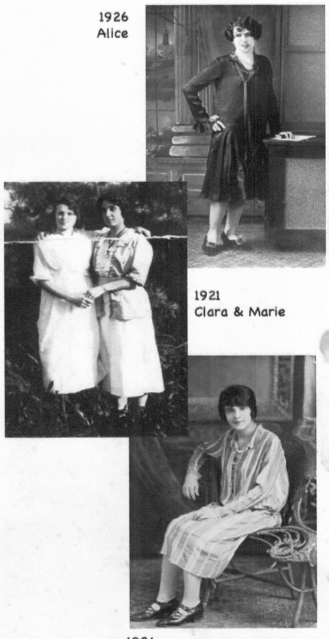

1941
Alphonse (father) - Clovis - Alphonse
- Ludger Tremblay - Pierre (kneeling)

1924
Rose Anna

7

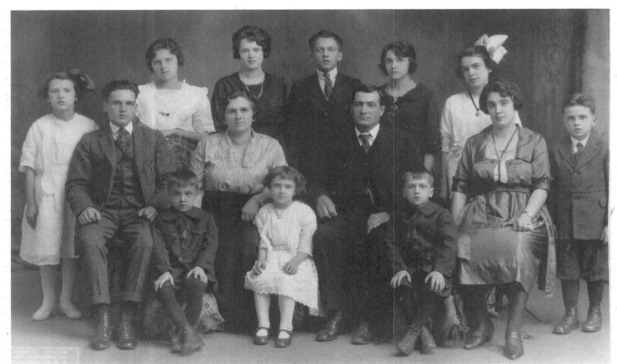

1922
(standing)
Aurelia - Rose
Anna - Clara -
Clovis -
Eugenie - Alice
- Pierre

(seated) Joseph
- Aphee -
Eugenie
(mother) -
Yvonne -
Alphonse
(father) -
Alphonse -
Marie

1943
Rose Anna - Nelson
Marcoux - Aurelia -
Clovis - Clara - Phil
Metevier - George Elliott
- Marie - Christe
Gaudreau - Eugenie

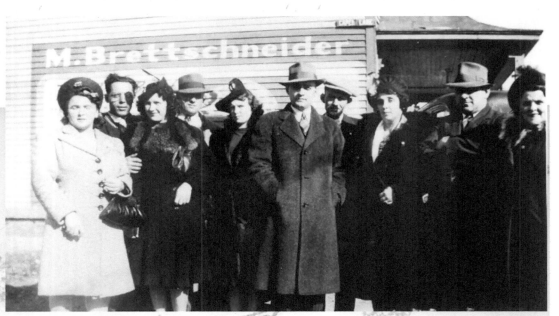

8

July 3, 1950
Marie (Morin) Elliott is standing directly behind her father Alphonse Morin

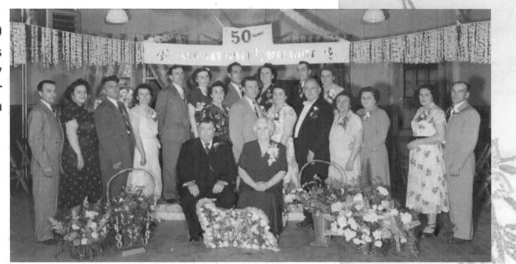

1916
(rear) Clovis - Eugenie - Marie - Clara- Joseph
(front) Aurelia - Alphonse (father) (holding) Alphee & Alphonse -
Pierre - Eugenie (mother) (holding) Yvonne - Alice - Rose Anna

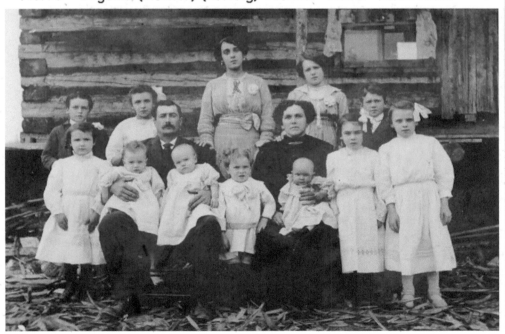

9

Laflamme-Morin Family's Life and Love

Alphonse Morin retired from Woods Manufacturing, Welland, Ontario in January 1950 where he'd worked for at least five years. On July 3, 1950, he and Eugenie (Laflamme) celebrated 50 years of marriage.

By 1950, the Morins' twelve children had married and had families of their own. At the time of their anniversary, the Laflamme-Morin family had grown to include 43 grandchildren, including our mother: Evelyn Elliott Menzone, and 3 great-grandchildren.

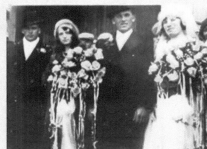

04/08/1931
Joseph & ? - Clovis & Leona
(Dupuis) Morin

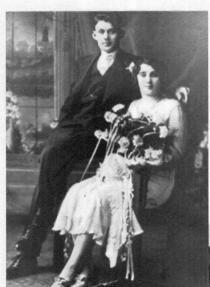

04/06/1926
George & Marie (Morin) Elliott

01/03/1942
Cadotte Family
Blanche - Eugenie -
Grace - Anna May

07/03/1950
Alphonse & Eugenie
(Laflamme) Morin

08/13/1956
Eugenie (Laflamme) Morin

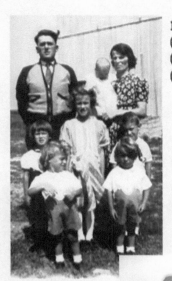

1941
(rear) Clovis-Cecile-Leona
(mid) Lydia - Doris - Eddy
(front) Jules - Julien

11/25/1965
Eugenie - Marie - Philippe Metevier

1936
Ludger & Yvonne Tremblay

1949
Clara & Philippe Metevier
25th Anniversary

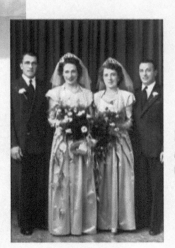

06/23/1982
Marie - Eugenie - Alice

1936
Alphonse & Laura (Picard) Morin
(?) & Alphee

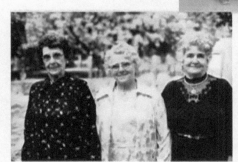

11

07/1990
Marie - Christe & Rose Anna
Gendreau - Eugenie

1941
Joseph - Alphonse
Georgette - Theresa - Roger
(Joseph's children)

1941
(rear) Alice's sons Ronald & Roland
(front) Clovis' boys Jules & Julien

04/1942
Eugenie & Eusebe Picard

07/1987
Marie - Eugenie - Alice

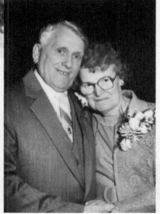

1981
Clovis & Leona Morin
50th Anniversary

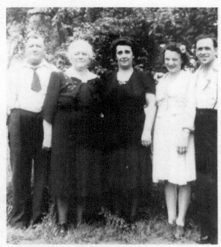

07/1945
Alphonse & Eugenie Morin - Marie
- Cecile & Pierre Morin

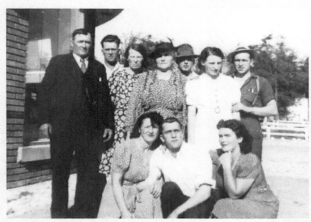

1941
Alphonse (father) - Clovis & Leona - Eugenie
(mother) - Pierre & Cecile - Joseph
(front) Aurelia - Alphonse - Alice

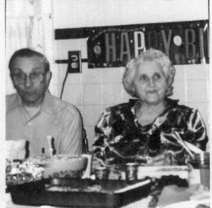

04/23/1991
Alphee - Eugenie

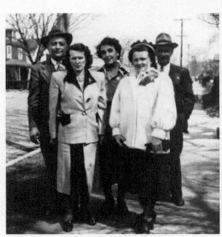

1953
Philippe & Clara Metevier - Marie -
Eugenie - Eusebe Picard

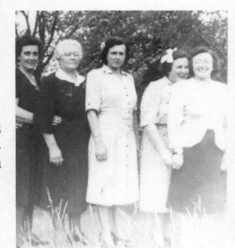

07/1945
Marie - Eugenie - Clara -
Eugenie - Rose Anna

13

A Barn and a Horse

My mother (Marie Morin Elliott) never liked to talk about it (her childhood). They were 18 children living in a barn (background in 1916 family photo, page 9). They were farmers; her sisters were chicken farmers later, but I don't know what they farmed back then (1901-1926). In the winters, her father would walk for miles to the nearest city to get work. He'd be gone for months and in the barn, the children would scrape the frost off the windows to see if he was coming home.

There was a story among relatives that her mother (Eugenie Laflamme Morin) was sick and because she had all of those children at home needing care, her family, who were very religious, went to see the priest and they asked him to promise that she would recover but the priest shook his head and told them that the payment for such a promise was too great. The story goes that her family prayed anyway and Eugenie recovered, but the 3-year-old and another baby died instead.

The town (Canaan) thought they (Alphonse & Eugenie Morin) were rich because they owned a horse. That was later (1927) when they also had a house. No one else in town had a horse. It must have been used on the farm.

Evelyn Menzone

Author's Note: It is presumed the 3-year-old was Aimee Morin, mentioned in US immigration documents in 1921, missing from the 1922 family photograph, and never spoken of during Mom's lifetime. The other "baby" must have been a newborn. Marie Morin Elliott did say her mother had had many miscarriages and still births, plus illness took a few shortly after birth.

07/24/1928
Doris Elliott

14

Goodrow – Elliott

Family

(circa 1877 – 1945)

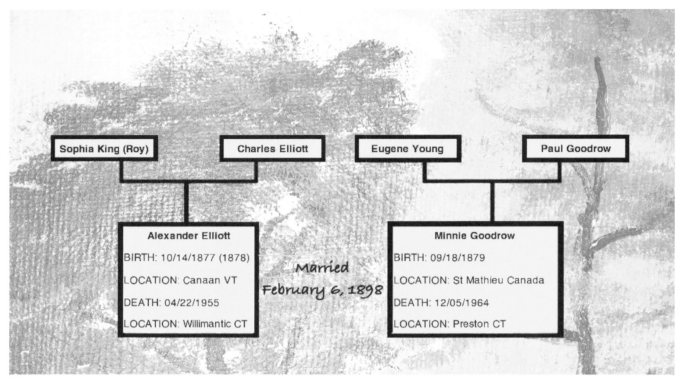

| Sophia King (Roy) | Charles Elliott | | Eugene Young | Paul Goodrow |

Alexander Elliott

BIRTH: 10/14/1877 (1878)

LOCATION: Canaan VT

DEATH: 04/22/1955

LOCATION: Willimantic CT

Married
February 6, 1898

Minnie Goodrow

BIRTH: 09/18/1879

LOCATION: St Mathieu Canada

DEATH: 12/05/1964

LOCATION: Preston CT

Alexander had at least one brother: John Elliott.

Nothing is known about either Alexander's or Minnie's parents except their names.

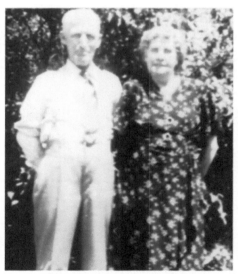

Alexander & Minnie Elliott
1950

At times, Minnie's maiden name was spelled: Goodreau. It is unknown if she had any siblings.

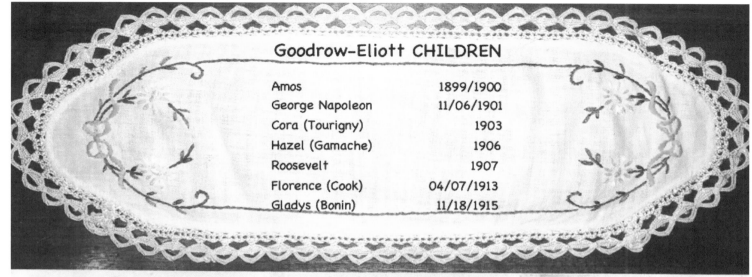

Goodrow-Eliott CHILDREN

Amos	1899/1900
George Napoleon	11/06/1901
Cora (Tourigny)	1903
Hazel (Gamache)	1906
Roosevelt	1907
Florence (Cook)	04/07/1913
Gladys (Bonin)	11/18/1915

1916
George - Adelard Sampson

1920
Florence - Gladys

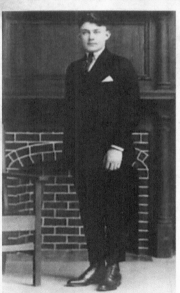

1918
George

17

1919
Arthur Elliott (cousin) - George Elliott
- Leo Fradette

1921
George - friend

1919
George Elliott - Christy Goudreau
- Joseph Morin

1916
Adelar Sampson - George -
Carmile (?)

1922
Florence - Gladys

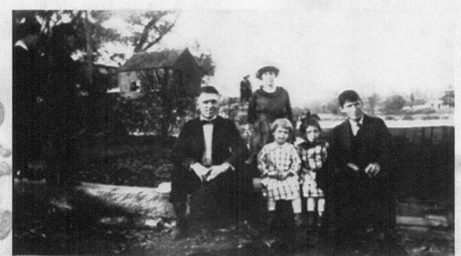

1920
(off to left) Cora & Hazel
Alexander - Minnie -
Florence - Gladys -
George

1943
(standing) Hazel - Roosevelt - Cora - George - Florence - Amos
(seated) Minnie - Gladys - Alexander

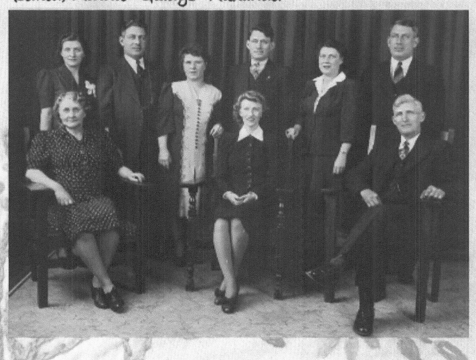

Goodrow-Elliott Family's Life and Love

Alexander Elliott was born in Canaan, Vermont. It is unknown when he moved to Willimantic, Connecticut. He worked for 25 years at American Thread in Willimantic as a steam-fitter before retiring. He also worked as a school traffic policeman.

Alexander and Minnie had seven children. It is unknown if Roosevelt Elliott married. The other six children married and had families of their own. In 1955, at the time of Alexander's death, the Goodrow-Elliott family had grown to include twenty-three grandchildren (one of which is our mother Evelyn Elliott Menzone) and three great grandchildren.

Minnie Elliott lived until 1964.

Pray for the Repose of the Soul of
Alex Elliott
BORN OCT. 14, 1878
DIED APRIL 22, 1955

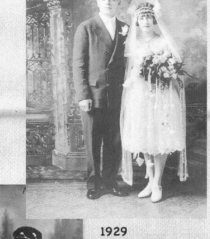

1929
Albert & Hazel Gamache

04/06/1926
Roosevelt Elliott

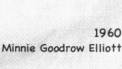

1920s
Amos & Pheobe Elliott

1960
Minnie Goodrow Elliott

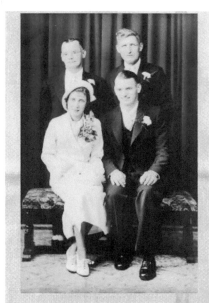

1940
Alexander Elliott - Mr. Cook
Florence & Clifford Cook

1920s
Harvey & Cora Tourigny

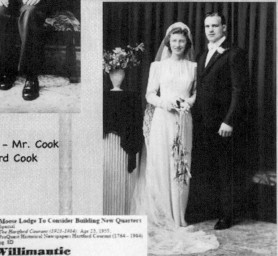

1936
Gladys & Gene Bonin

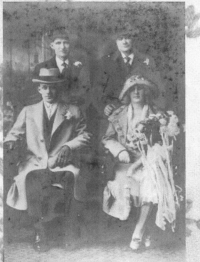

1926
Alexander Elliott - Alphonse Morin
George & Marie Elliott

Moose Lodge To Consider Building New Quarters
Special
The Hartford Courant (1923-1984); Apr 23, 1955;
ProQuest Historical Newspapers Hartford Courant (1764 - 1984)
pg. 5D

Willimantic

Alex Elliott

Alex Elliott, 77, of 60 Ives St., died Friday morning after a short illness at the Windham Community Memorial Hospital.

He was born in Wallis Pond, Vt. Oct. 14, 1877, a son of Charles and Sophie (Roy) Elliott, and for 25 years was a steam-fitter with the American Thread Co. He was also a school traffic policeman here. He was a communicant of St. Mary's Church.

He leaves his wife, Mrs. Minnie (Goodreau) Elliott; four daughters, Mrs. Harvey Tourigny, Mrs. Hazel Gamache, Mrs. Clifford C. Cook and Mrs. Gene Bonin; two sons, Amos and Roosevelt Elliott; a brother, John Elliott, all of this city; 24 grandchildren; three great-grandchildren; and several nieces and nephews.

Services will be held from the Bacon Funeral Home, 71 Prospect St., Monday at 8:15 a.m. and in St. Mary's Church at 9. Burial will be in St. Joseph's Cemetery.

Friends may call at the funeral home Saturday and Sunday from 2 to 5 and 7 to 10 p.m.

Canaan, Vermont

Considered an international lake, two-thirds of Wallis Pond (aka Wallace Pond or Wallace Lake) is located in Canada, one-third in the United States. On its east coast lies Canaan, Vermont, a small, rural town established by Canadians from Quebec. Immigration records show the Goodrow-Elliotts moving back and forth across the border multiple times early in the 20th century. In 1895, the United States' census reported that Canaan had a population of 616 and the Morin-Elliotts of Willimantic, Connecticut, have said that a knock on just about any door in Canaan would reveal a relative of ours.

Buckland, Canada is part of Quebec and around 1907, the Laflamme-Morin family had migrated towards the Canaan area where Marie Morin first met her future husband, George Elliott. The two families had always been close friends.

At the turn of the 20th century, employment in Canaan consisted of farming, working in the Ethan Allen furniture factory (established in 1884), or logging (a trade visible in the background of the 1941 photo on page 5).

Although many of our ancestors remained in Vermont and Canada, several others moved southward, travelling on foot, including Marie Morin and George Elliott, and eventually settled in Willimantic.

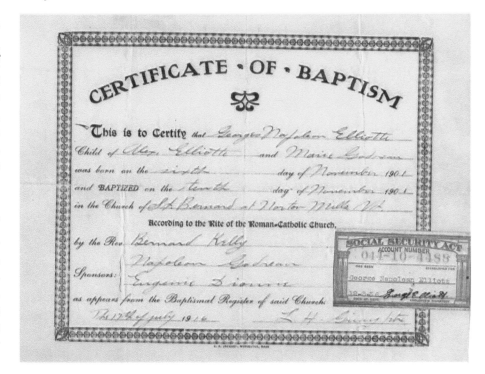

22

George and Marie

When Marie Morin was young, she had other suitors. However, her heart must have been set on George Elliott because she waited for him. The story has it that she asked him, or demanded of him, to marry her because she was 26 years old and it was about time they were married! They were married in Willimantic, Connecticut, where both were working for American Thread at the time.

When George was young, he fell on the railroad tracks just as a train was coming. His father grabbed him, literally, by the seat of his pants and pulled him away. George lost part of his hand from that accident and the trauma gave him a heart condition. Eventually, the heart condition is what took his life much too early for the family.

1920s Marie Morin & George Elliott

(Recipe For making patties)
2 Eggs
1 teaspoonful of sugar.
1/4 teaspoonful of salt.
1 cup of milk!
1 cup of flour.

Rosette

From bébé chawer
1928, Marie P. Elliott

above amount will about forty patties
Beat the eggs slightly, add sugar, salt.
and milk, Stir in flour gradually
and beat until smooth.
Screw handle into mold. Dip iron into
hot lard or oil, then into batter, not
allowing batter to come over top of the
iron, Fry for at least 20 seconds
But not more than 35 seconds, Remove
from iron with a clean piece of cheesecloth,
and allow to cool before serving
Should the batter fail to adhere to the mold the
iron is probably overheated. if the patties blister
undoubtedly the eggs are beaten too much.
to insure crisp patties they should be fried
somewhat moderately, Patties sufficiently fried
Will come from the irons freely. (good Recipe)

Author's Note: These molds were a 1928 baby shower gift. Marie Morin Elliott primarily spoke and wrote in her native French; so the recipe must have been copied at a later date. Below are the two molds and one of the mold-handles that came with the recipe. The heart is 3" across, the circle 2"; both are 1.5" tall. I haven't tried the recipe, but know that Marie had to have patience to make only 2 cakes at a time with a recipe that makes 40 cakes!

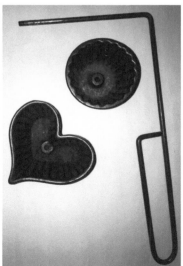

Morin – Elliott

Family

(1901 - 1998)

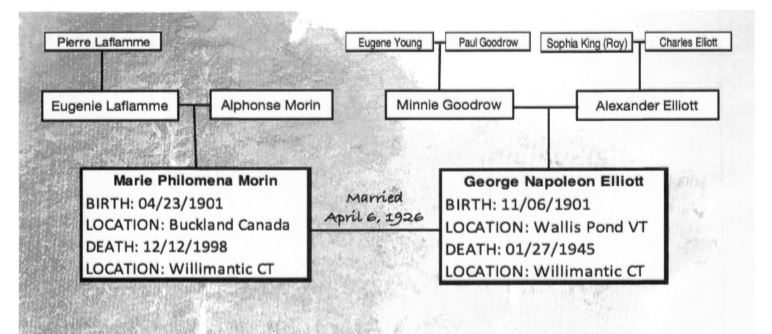

| Pierre Laflamme | | Eugene Young | Paul Goodrow | Sophia King (Roy) | Charles Elliott |

| Eugenie Laflamme | Alphonse Morin | Minnie Goodrow | Alexander Elliott |

Marie Philomena Morin
BIRTH: 04/23/1901
LOCATION: Buckland Canada
DEATH: 12/12/1998
LOCATION: Willimantic CT

Married April 6, 1926

George Napoleon Elliott
BIRTH: 11/06/1901
LOCATION: Wallis Pond VT
DEATH: 01/27/1945
LOCATION: Willimantic CT

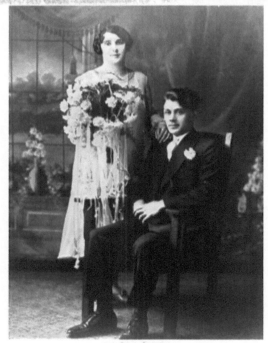

04/06/1926
Marie (Morin) & George Elliott

26

1949
Doris - Janet

Morin - Elliott
Children

Doris	03/17/1927
Raymond	07/27/1928
Janet (Matassa)	11/01/1931
Ruth (Roy)	02/03/1933
Carl	11/26/1934
Evelyn Helen (Menzone)	03/23/1936
Edith (Baronousky)	02/06/1938
Marie Shirley	11/07/1939
Robert	06/23/1942

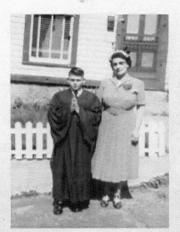

1952
Robert - Marie (Morin) Elliott

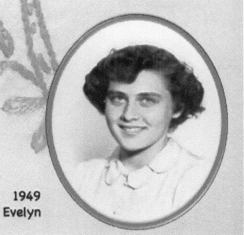

1949
Evelyn

27

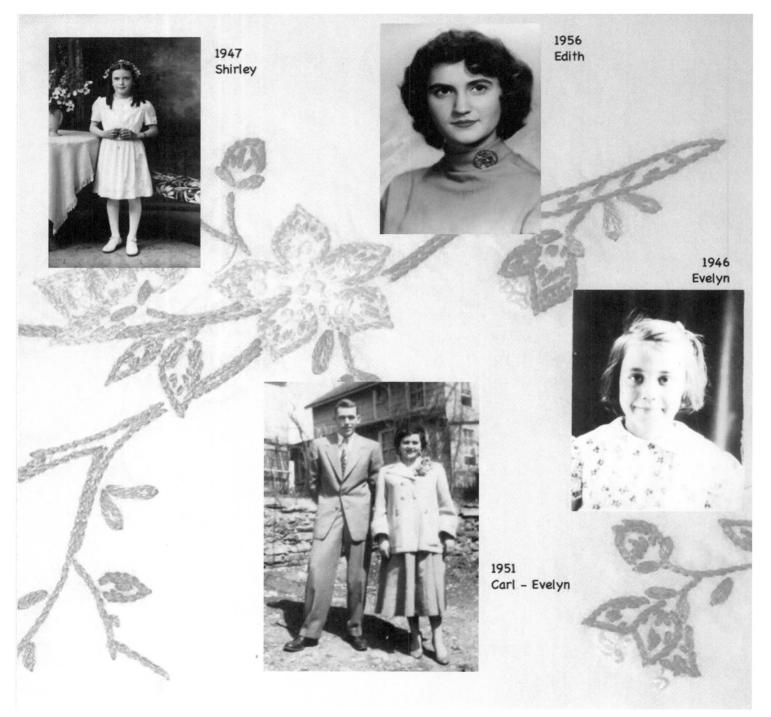

1947
Shirley

1956
Edith

1946
Evelyn

1951
Carl - Evelyn

28

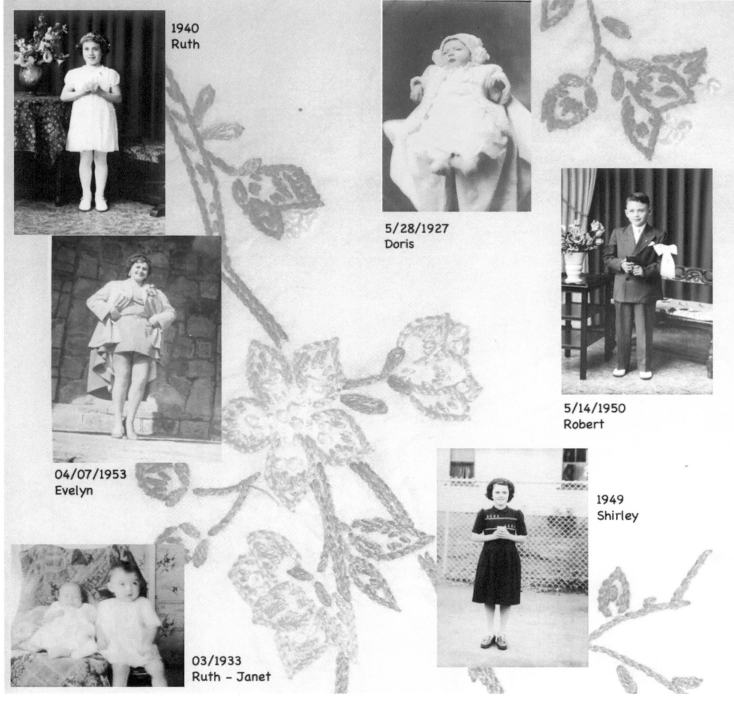

1940
Ruth

5/28/1927
Doris

5/14/1950
Robert

04/07/1953
Evelyn

1949
Shirley

03/1933
Ruth - Janet

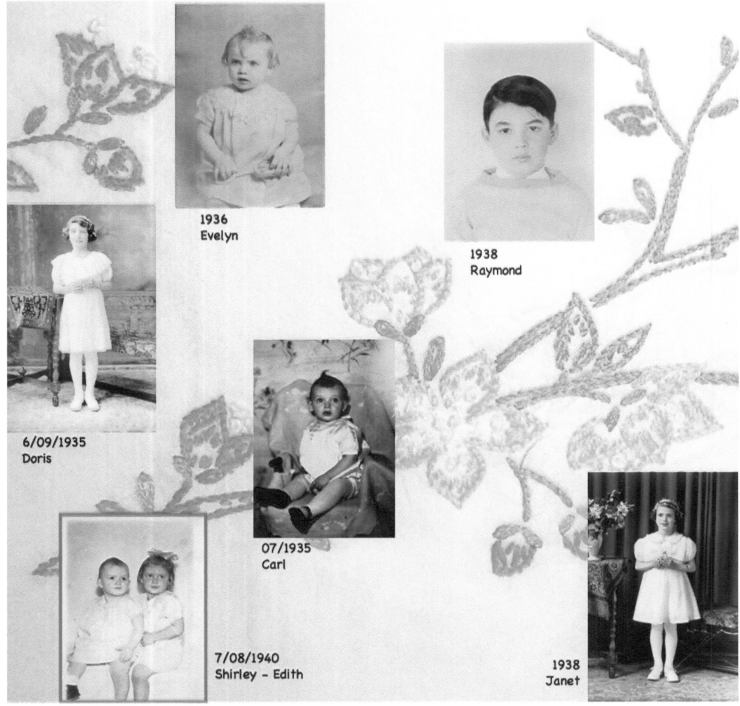

1936
Evelyn

1938
Raymond

6/09/1935
Doris

07/1935
Carl

7/08/1940
Shirley - Edith

1938
Janet

30

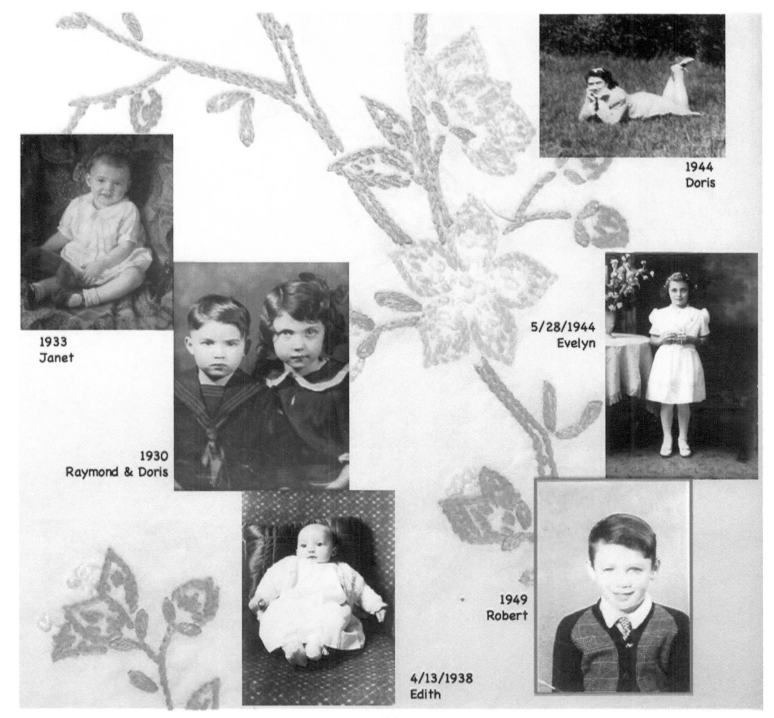

1944
Doris

1933
Janet

5/28/1944
Evelyn

1930
Raymond & Doris

1949
Robert

4/13/1938
Edith

31

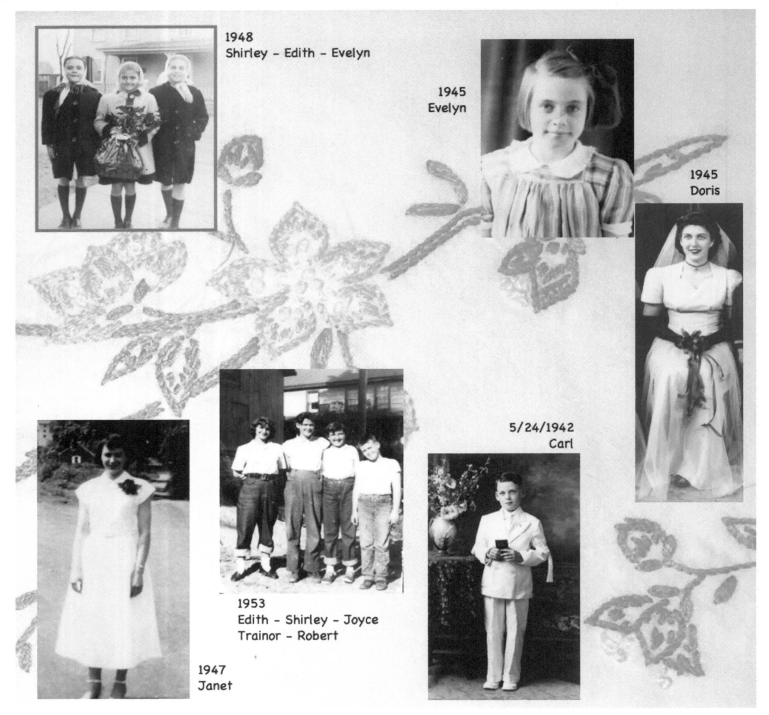

1948
Shirley - Edith - Evelyn

1945
Evelyn

1945
Doris

5/24/1942
Carl

1953
Edith - Shirley - Joyce
Trainor - Robert

1947
Janet

32

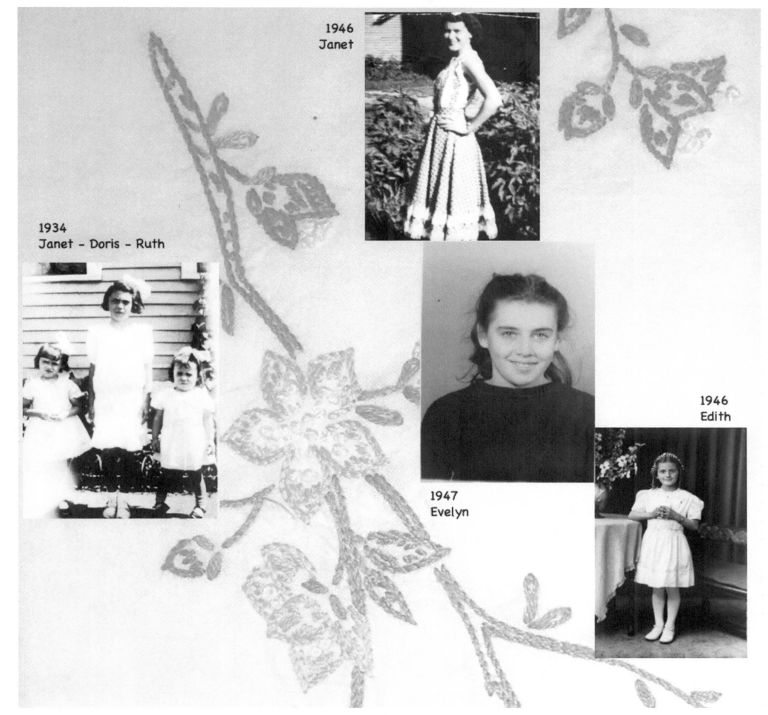

1946
Janet

1934
Janet - Doris - Ruth

1947
Evelyn

1946
Edith

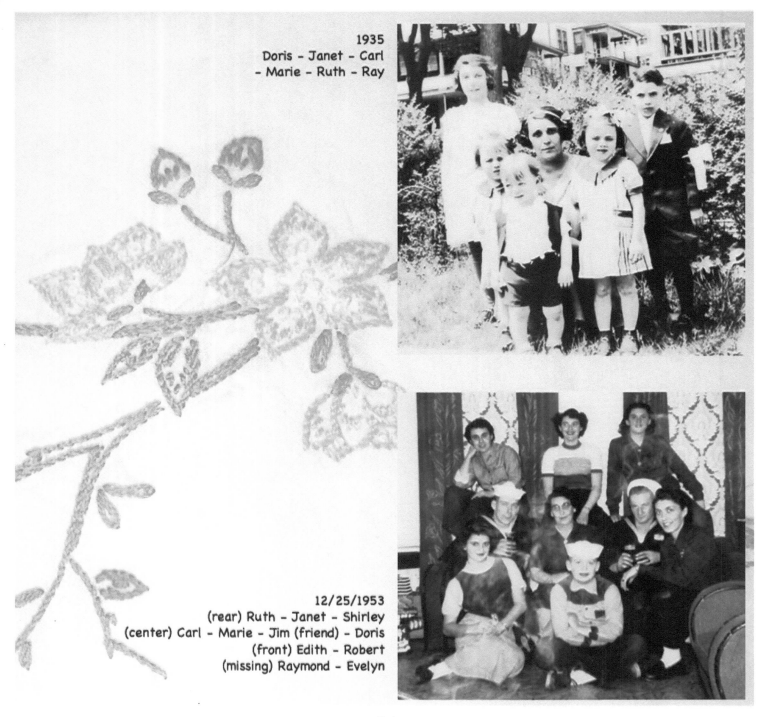

1935
Doris - Janet - Carl
- Marie - Ruth - Ray

12/25/1953
(rear) Ruth - Janet - Shirley
(center) Carl - Marie - Jim (friend) - Doris
(front) Edith - Robert
(missing) Raymond - Evelyn

34

1943
Ray - Doris
Carl - Ruth - Janet
George - Robert - Edith - Evelyn - Shirley - Marie

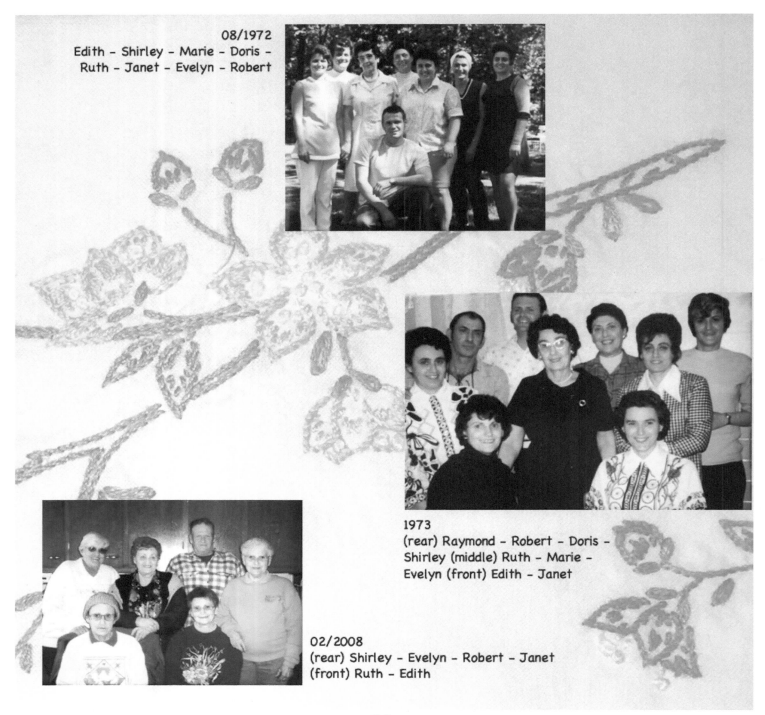

08/1972
Edith – Shirley – Marie – Doris –
Ruth – Janet – Evelyn – Robert

1973
(rear) Raymond – Robert – Doris –
Shirley (middle) Ruth – Marie –
Evelyn (front) Edith – Janet

02/2008
(rear) Shirley – Evelyn – Robert – Janet
(front) Ruth – Edith

36

The Morin-Elliott Family's Life and Love

Marie (Morin) Elliott lived a long, love filled life. She was dependable, resourceful, and intuitive. She enjoyed being with family - her Canadian relatives, her children, and her grandchildren.

Her life was not without tragedy or sadness. She outlived her husband, two of her children, two son-in-laws, and most of her siblings.

Every day, until the end, she arose from bed and faced the day with new vigor. She was a remarkable woman.

01/27/1945
George Elliott

10/15/1993
Marie - Daniel Menzone

12/12/1998
Marie Philomena (Morin) Elliott

04/23/1997
Marie (Morin) Elliott

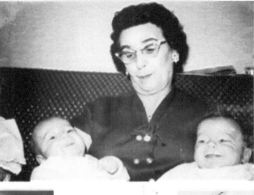

10/1962
Marie & the Roy Twins

12/25/1972
Shirley - Edith - Evelyn - Marie
Johnny Baronousky

06/06/1953
Janet Elliott Matassa

1947
Lucille (Tarney) &
Raymond Elliott

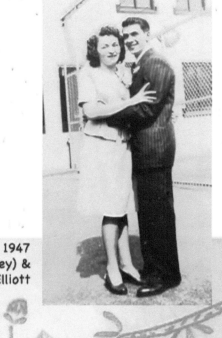

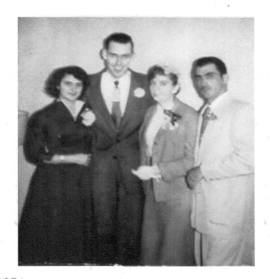

1954
Edith - Carl & Alice (Dort) Elliott - Raymond

1958
(rear) Marie - Janet
(front) Robert - Doris - Ruth & Rob Roy

06/1947
Raymond - Ronnie - Lucille

06/06/1953
Janet (Elliott) & Thomas
Matassa

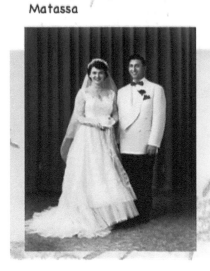

1994
Mark Baronousky & Marie

11/1974
Marie Elliott

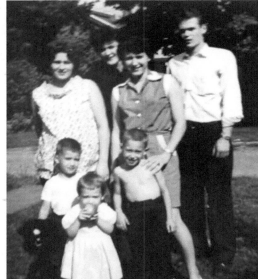

07/1961
(rear) Evelyn - Shirley -
Janet - Robert
(front) Tony Menzone -
Karen & Mical Matassa

1956
Evelyn - Doris - Ruth - Edith -
Shirley - Marie - Janet

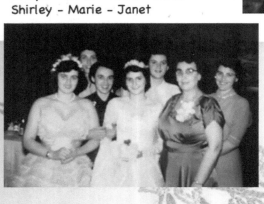

06/1947
Ronnie
Elliott

1968
(rear0 Carl & Alice Elliott
(front) Debbie - Carl Jr - Tammy

04/23/1995
Marie Elliott

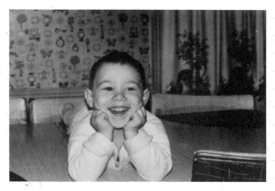

1963
Randy Roy

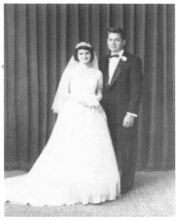

1956
Edith & Bob Foley

07/01/1955
Ray Elliott & Irene Riopel

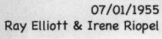

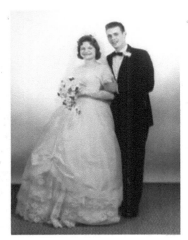

1963
Robert & Nancy Elliott

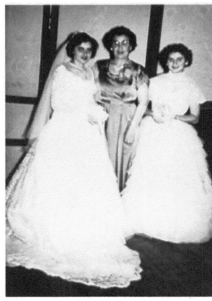

11/27/1954
Evelyn - Marie - Edith

12/25/1962
Marie - Carl Jr

04/1982
Marie

1983
Rob & Ruth Roy
25th Anniversary

42

1955
Marie & Mical Matassa

1976
Rene & Ryan Roy

07/1967
Tina - Robert

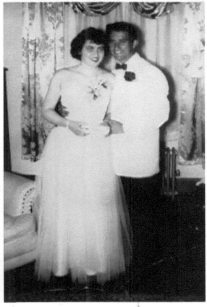

1/20/1954
Evelyn Elliott -
Joseph Menzone

03/17/2002
Doris - Evelyn - Nancy

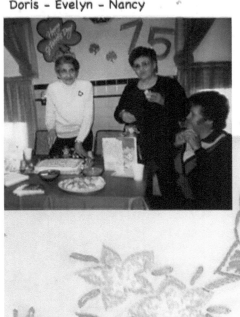

1993
Doris - Shirley - Marie

1976
Karen Matassa

12/1989
(rear) Robert Jr - Tina
(front) Robert - Nancy

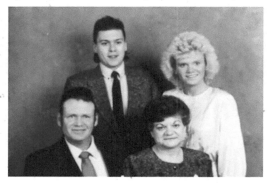

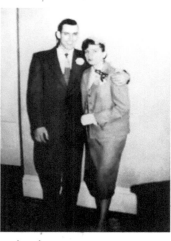

11/03/1956
Carl & Alice (Dort) Elliott

07/11/1997
Marie (Morin) Elliott

08/13/1977
Debbie - Marie

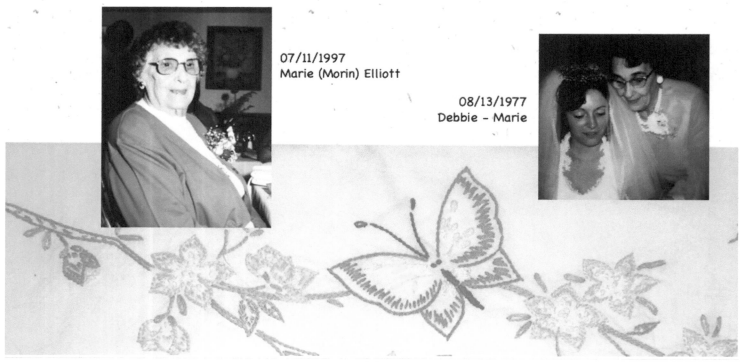

44

1977
Marie

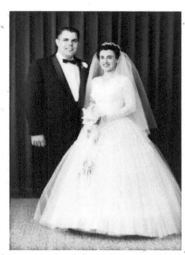

1958
Ruth (Elliott) & Rob
Roy

12/10/1966
Edith & Roger
Baronousky

1966
Carl Jr – Carl – Raymond – Robert – Tammy

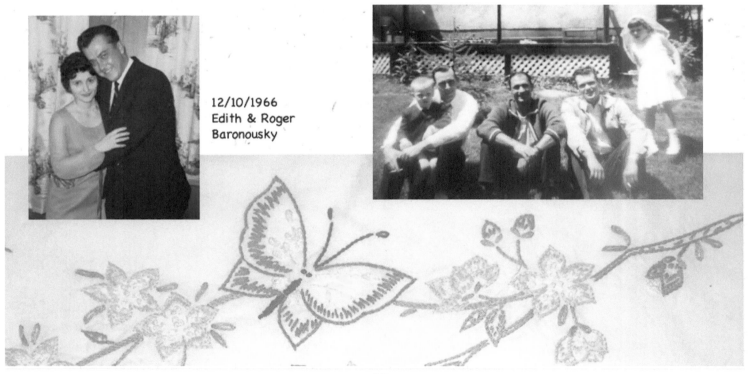

45

Morin – Elliott Grandchildren

Child	Spouse	Grandchildren		
Doris	Unmarried			
Raymond	Lucille (Tarney) (dv)	Ronnie		
	Irene (Riopel)			
Janet	Thomas Matassa	Mical	Karen	James
Ruth	Robert Roy	Randy	Rene	Ryan
Carl	Alice Dort	Debbie	Tammy	Carl Jr
Evelyn	Joseph Menzone	Anthony	Daniel	
Edith	Robert Foley (dv)	Mark		
	Roger Baronousky	John		
Shirley	Unmarried			
Robert	Nancy	Tina	Robert Jr	

(top) 1961 Ronnie Elliott, Mical Matassa (13yo), Carl Elliott Jr, Tina Elliott (4yo)
(center) Mark (Foley) Baronousky (11yo), James Matassa, Tina Elliott, John Baronousky
(bottom) Robert Elliott Jr (8mo), John Baronousky, Rene-Randy-Ryan Roy, Debbie-Tammy-Carl Jr Elliott
(missing Karen Matassa, Anthony Menzone, Daniel Menzone)

Spruce Street

The Morin-Elliott family lived in Willimantic, Connecticut, known affectionately as "Willi" by the children. The town had a grand main street with storefronts, malt shops, and dance halls and the leading industry was the American Thread factory. Most everything a family of the 1930s-1950s era needed was within walking distance.

> *Everyone liked him [George Elliott]. When we needed a new place, he'd go alone and woo the woman [landlord] into renting and at lower rent. Next day, I show up with the children in tow. She yells and he hides until we are settled. I had too many children and they all thought we'd be loud and messy. But he'd paid her, so we stayed.*
>
> *Everywhere we went, it was: "that woman with all those children."*
>
> Marie Elliott

Finding apartments large enough for a family of eleven was difficult and George had his basket of tricks to keep the landlords happy. The older children minded their younger siblings and everyone had their chores. Most of the landlords grew to like the family, but the stigma of coming from a large family did always haunt them. When George passed away in 1945, social services paid the Morin-Elliott family a visit, claiming that a single, widowed woman couldn't care for nine children. The aim was to separate the family, sending the children to other homes.

> *We had to tell her if we found a penny on the street or if anyone gave us a (monetary) gift. I was only eight and she was awful to us. When she said she was taking Bobbie and Shirley, my sister Doris threw her down the stairs, into the street. No one was taking us from our mother.*
>
> Evelyn Menzone

Marie worked hard in those years after George's death. It is unclear what schooling, if any, she'd had as a child in Canada and later in Vermont. Perhaps because of social services, in 1945 Willimantic, Marie went back to school so that she could become a naturalized citizen of the United States.

I studied every day. I knew everything about America's history. It was a hard test. I had to use English for everything.

Marie Elliott

Marie continued working at American Thread and her oldest children, Doris and Ray, took jobs, too, while the other children were still in school, to help the family. Slowly, Marie saved her pennies and in 1953, she became the proud owner of her own home at 23 Spruce Street, Willimantic, CT, where she lived until her death in 1998.

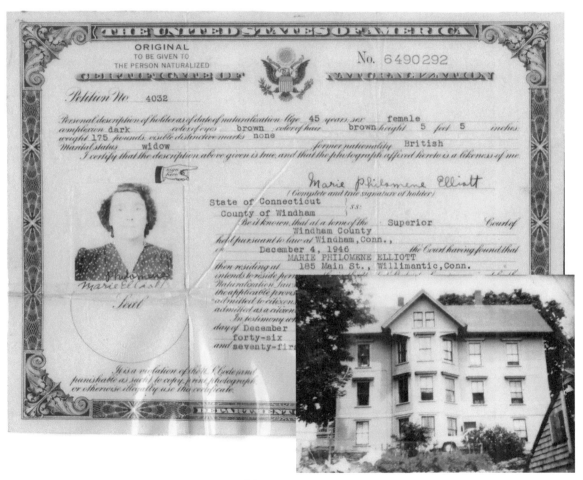

Travel and Automobiles

Even when cars became popular and common, it was hard for the extended Morin or Elliott families to get together. Canada was a long, long trip. Oftentimes, only Ma's sister or brother and their families would make the trip to Willimantic. A visit from Canada was a big deal. There were no hotels or restaurants, we were expected to put them up and feed them. For that reason, we kids (the Morin-Elliott family) knew of aunts or uncles (by name and stories), but never actually met them.

On one trip, Uncle Peter (Pierre Morin) came down in his new car. During his stay, he wanted to visit some other family. I don't know how it happened, but Evie (Evelyn Elliott Menzone) ended up driving. We didn't know, none of us, but the speedometer was in kilometers – so here's Evie driving along and being stopped for speeding!

Edith Baronousky

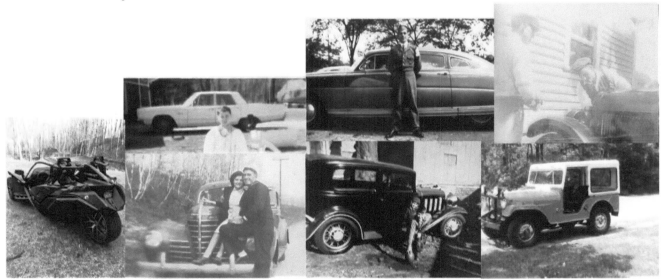

(top) 1970 Dan Menzone, 1950 Carl Elliott, 1930 George & Amos Elliott (bottom) 2018 Slingshot, 1945 Clara & Anthony Menzone, 1952 Bobby & Ronnie Elliott, 1979 (1967 CJ5)

Cormier - Lapreay

Family

(1848 – 1960)

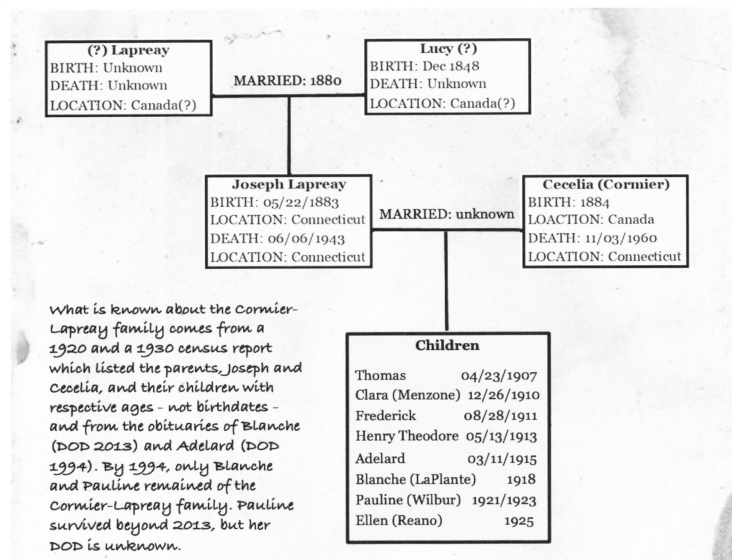

(?) Lapreay
BIRTH: Unknown
DEATH: Unknown
LOCATION: Canada(?)

MARRIED: 1880

Lucy (?)
BIRTH: Dec 1848
DEATH: Unknown
LOCATION: Canada(?)

Joseph Lapreay
BIRTH: 05/22/1883
LOCATION: Connecticut
DEATH: 06/06/1943
LOCATION: Connecticut

MARRIED: unknown

Cecelia (Cormier)
BIRTH: 1884
LOACTION: Canada
DEATH: 11/03/1960
LOCATION: Connecticut

Children

Thomas	04/23/1907
Clara (Menzone)	12/26/1910
Frederick	08/28/1911
Henry Theodore	05/13/1913
Adelard	03/11/1915
Blanche (LaPlante)	1918
Pauline (Wilbur)	1921/1923
Ellen (Reano)	1925

What is known about the Cormier-Lapreay family comes from a 1920 and a 1930 census report which listed the parents, Joseph and Cecelia, and their children with respective ages - not birthdates - and from the obituaries of Blanche (DOD 2013) and Adelard (DOD 1994). By 1994, only Blanche and Pauline remained of the Cormier-Lapreay family. Pauline survived beyond 2013, but her DOD is unknown.

The Putnam St. Mary's Cemetery has a grave for Clara's brother, Frederick Laprey (1911 - 1979) and another for Lucy Laprey (1852 - 1909) who might be Clara's paternal grandmother. I have found no records for Cecelia Cormier and it is unknown if she came alone from Canada or how and where she met Joseph Lapreay. The Cormier-Lapreay family lived in Putnam, CT.

1923
Clara Lapreay

1950
Cecelia Lapreay – Joseph Menzone

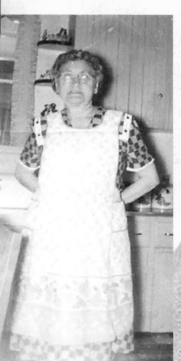

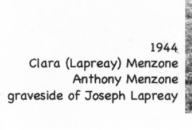

1944
Clara (Lapreay) Menzone
Anthony Menzone
graveside of Joseph Lapreay

2013
Blanche (Lapreay)
LaPlante

1950
Cecelia Lapreay

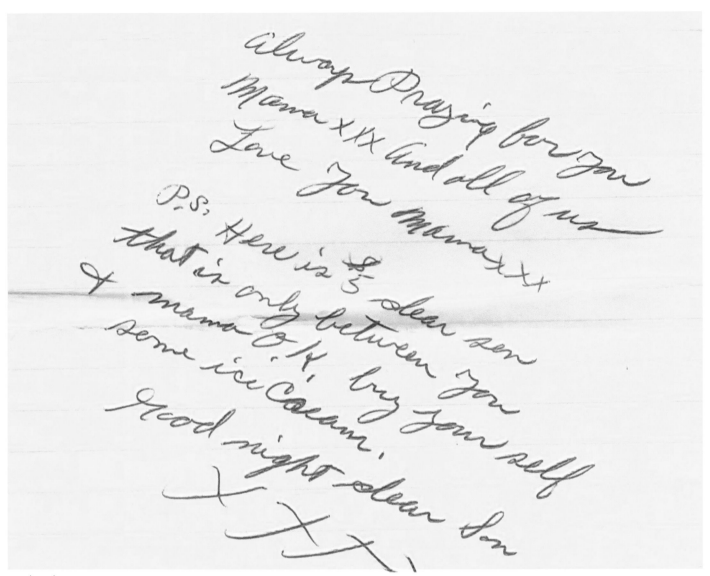

Always Praying for you

Mama xxx And all of us

Love You Mama xx

P.S. Here is $5 dear son
that is only between you
+ mama O.K. buy your self
some ice cream,
Good night dear son
X X X

01/31/1954
Clara Lapreay Menzone
Closing paragraph in a letter to her son, Joseph Menzone

Brogge - Menzone

Family

(1877 – 1955)

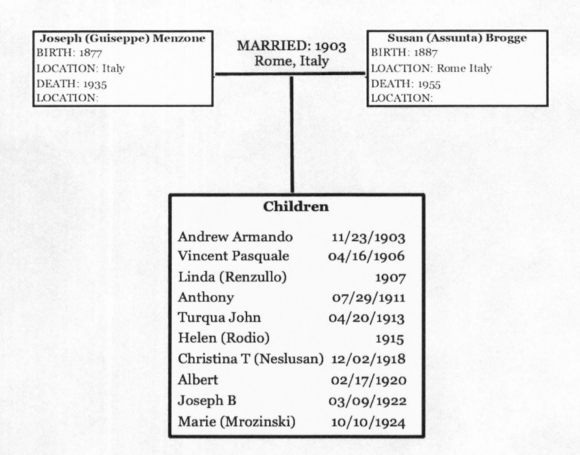

Joseph (Guiseppe) Menzone	MARRIED: 1903	Susan (Assunta) Brogge
BIRTH: 1877	Rome, Italy	BIRTH: 1887
LOCATION: Italy		LOACTION: Rome Italy
DEATH: 1935		DEATH: 1955
LOCATION:		LOCATION:

Children

Andrew Armando	11/23/1903
Vincent Pasquale	04/16/1906
Linda (Renzullo)	1907
Anthony	07/29/1911
Turqua John	04/20/1913
Helen (Rodio)	1915
Christina T (Neslusan)	12/02/1918
Albert	02/17/1920
Joseph B	03/09/1922
Marie (Mrozinski)	10/10/1924

Andrew, Vincent, and Linda were born in Rome, Italy. Anthony - our grandfather - was the first Menzone born in the United States, in Providence, Rhode Island.

Joseph had other brothers immigrate to the United States under the name Mizzoni. The difference in spelling is likely due to linguistics at the immigration office.

In some documents, Susan's maiden name is listed as "Braga."

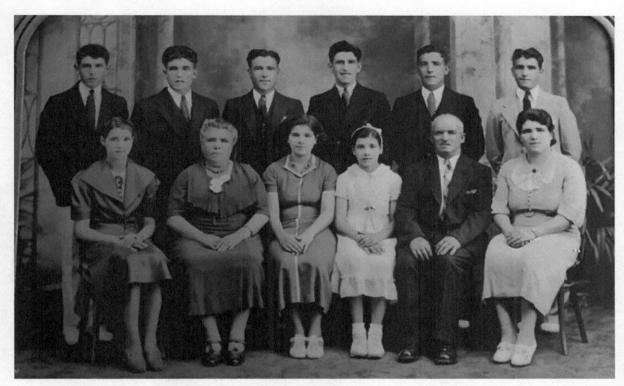

1934
(rear) Joseph B – Albert – Andrew – Anthony – Turqua – Vincent
(front) Helen – Susan (Assunta) – Christina – Marie – Joseph (Guiseppe) – Linda

1946
Anthony – Susan – Guiseppe – (?)

57

1950
Joseph B - Joseph Menzone

1946
Christina

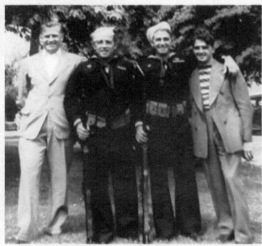

1946
John Neslusan - Turqua - Anthony - Albert

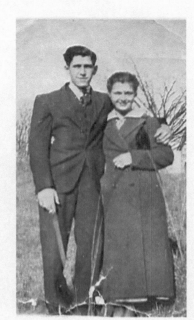

1934
Anthony - Marie

1946
Helen (Rodio)
Menzone

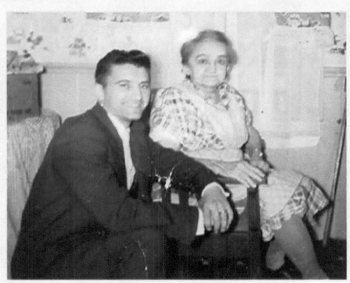

1950s
Joseph A. Menzone (dad) - Susan Menzone (meme)

Tony and Clara

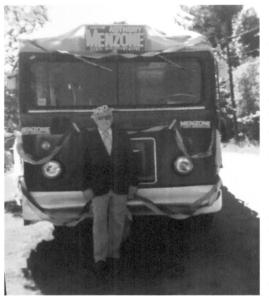

I met Dan Menzone December 23, 1986 and Clara (Lapreay) Menzone passed away January 8, 1987, so I never had the opportunity to meet her. I did get to know Tony (Anthony Menzone). He was always smiling and interested in my well-being asking me about school, congratulating me on my first, official job, and impressed that I learned how to scuba-dive, a sport he found intriguing but hadn't tried. He was a hard worker, a very successful businessman, and therefore he respected others who persevered through difficult times, making the effort to succeed. If you deserved praise – he readily gave it! – and he was never afraid to admonish you if you were lazy or doing something wrong.

Here Tony stands before the family bus getting ready for the 1975 elections. For a man who didn't graduate from high school, Tony had a natural ability to fix things and get things done on tight budgets. He had a work creed: "Pay the men for the whole day! Even if the job only lasted four hours!" He enjoyed being busy, being at work, and at work is where he was the day he passed away at 81 years-old.

Grampa was loud. People thought he was angry, but that was just his nature. Once we were out cutting firewood. I was just a kid, 8 or 9, and he just got done telling us to be careful throwing the logs into the truck bed. One of us tossed a log; it just slid across the top of the pile and tapped the truck's back window. No one said anything. A while later, Grampa opens the truck door to get something and the glass shatters all over the seat. He was angry, then, but he laughed. We all laughed.

Daniel Menzone

Both Tony and Clara were generous, loving people, not afraid to donate time, money, or property for the greater good of the communities of Webster and Dudley (Massachusetts).

Tony would get me to come with him on his deliveries. Early in the morning. He'd go here and there, dropping off turkeys and gifts to friends and family. He made sure everyone got something.

Evelyn Menzone

Clara lived for her family, her children and grandchildren, putting their needs and wants before her own. She loved to laugh and she loved to cook.

Meme always "just cooked" something. And if she hadn't, she cooked while talking. Most kids would go outside and play after dinner. With Meme, we went outside to lay in the grass, our stomachs were so full! She was always slipping a five or ten in the pocket of your coat or rolled into a [toy, dish, gift].
Daniel Menzone

1981 Clara Menzone

I missed out on those famous holiday feasts Clara used to prepare!

08/22/1953
Robert Menzone
Letter to his brother Joseph Menzone

Joe Menzone Remembers . . .

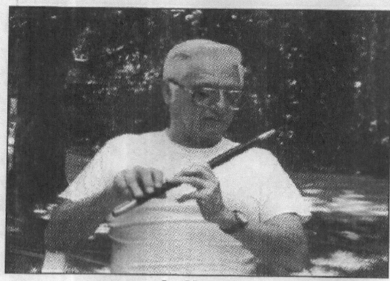

Joe Menzone

by Maureen Bounds

DUDLEY - Joe Menzone, a Dudley resident for nearly his entire life, proudly displays the fife which was once owned by his very special friend Ken Guerrier.

"I'm delighted to have this gift from Ken." says Joe. Through the years Joe has often tried to find a fife of this type, but has had no luck.

The fife, a 'B type', made of wood with silver ends is more than fifty years old and brings back many fond memories. Joe remembers being a young man of fourteen watching parades. One particular memory is of a drummer named Vernon Wagner, whose musical talent inspired Joe to join the Universal Fife and Drum Corp. and become a self-taught drummer.

large bright orange plume. Joe remembers that he was 'just a skinny kid' and the drum was almost too big for him to handle.

Ken and Joe have enjoyed a friendship for fifty years. Distance separates them now, Ken has moved to Florida, but they continue to keep in touch. A friendship of fifty years holds many memories - Joe remembers one in particular. There was a competition in Hartford, Conn., The Universal Fife and Drum Corp. was staying in a nearby hotel. "It was some sort of big celebration," says Joe.

"People were going crazy and it was a very hot evening. The fountain across the street near the Capitol looked cool and inviting.

Unfortunately, the entire article is not reproduced here. Dad always stressed the importance of friendship, perseverance, and commitment. Life is hard, no matter how you tackle it. Don't take it on alone, keep pushing for your dreams, and hold tight no matter how tough it gets.

Thanks Dad for the great advice!

The Patriot
07/31/1996

Lapreay - Menzone

Family

(1910 – 1992)

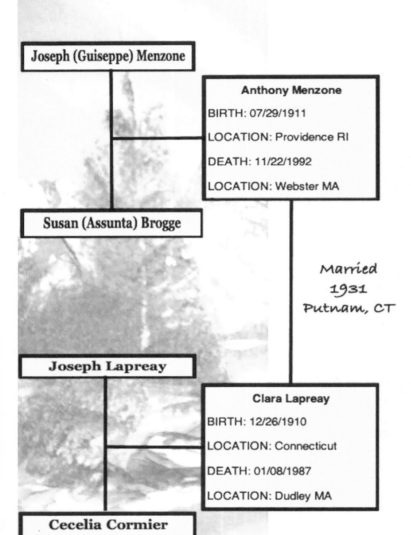

Joseph (Guiseppe) Menzone

Anthony Menzone
BIRTH: 07/29/1911
LOCATION: Providence RI
DEATH: 11/22/1992
LOCATION: Webster MA

Susan (Assunta) Brogge

Married
1931
Putnam, CT

Joseph Lapreay

Clara Lapreay
BIRTH: 12/26/1910
LOCATION: Connecticut
DEATH: 01/08/1987
LOCATION: Dudley MA

Cecelia Cormier

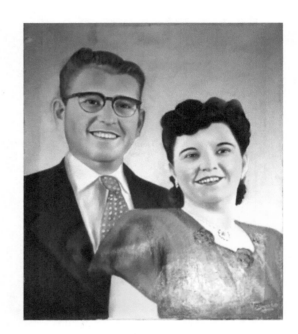

Clara and Tony's son, Joseph Menzone, had this painting commissioned in 1950 in Italy from a black & white photo taken circa 1940. The painting hung over the mantel at 11 Ellis Ave until 1993.

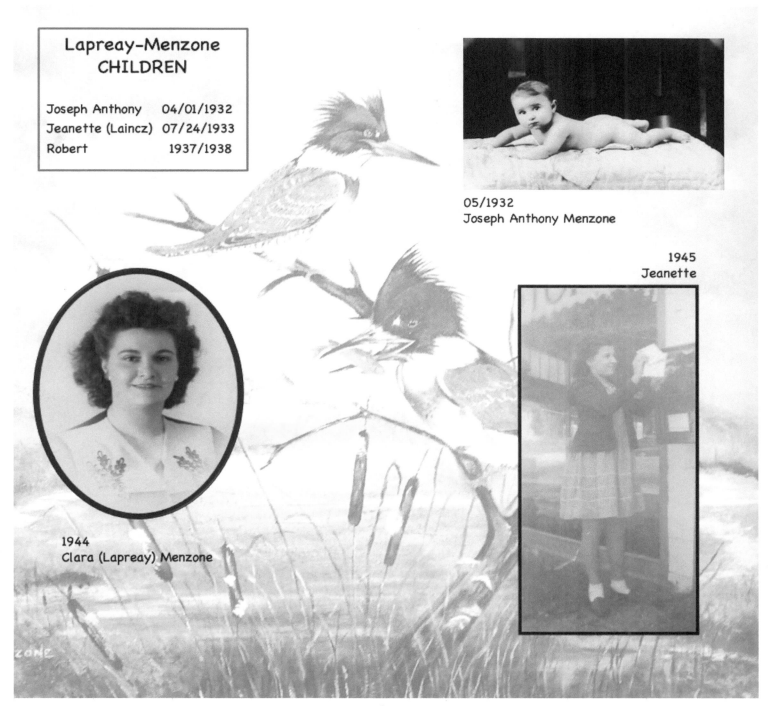

Lapreay-Menzone
CHILDREN

Joseph Anthony	04/01/1932
Jeanette (Laincz)	07/24/1933
Robert	1937/1938

05/1932
Joseph Anthony Menzone

1945
Jeanette

1944
Clara (Lapreay) Menzone

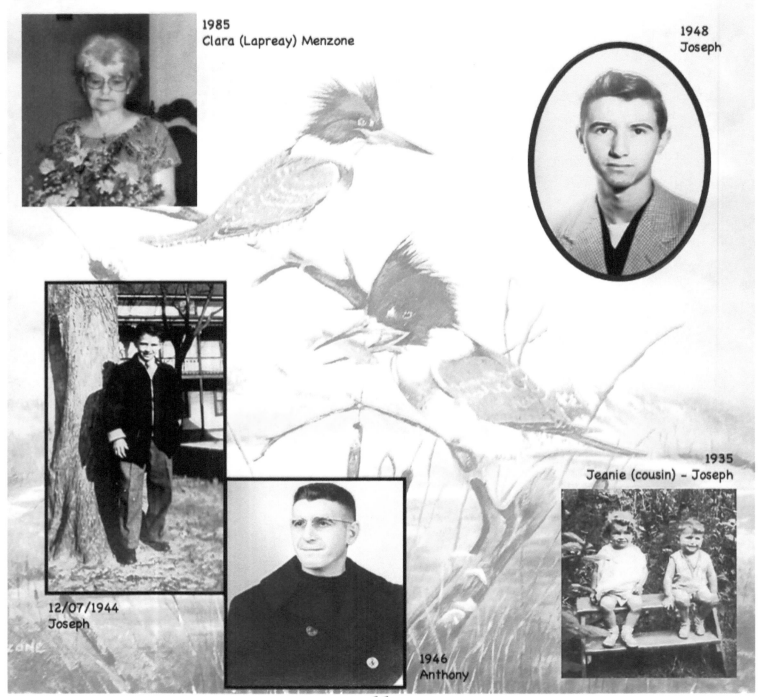

1985
Clara (Lapreay) Menzone

1948
Joseph

12/07/1944
Joseph

1946
Anthony

1935
Jeanie (cousin) - Joseph

66

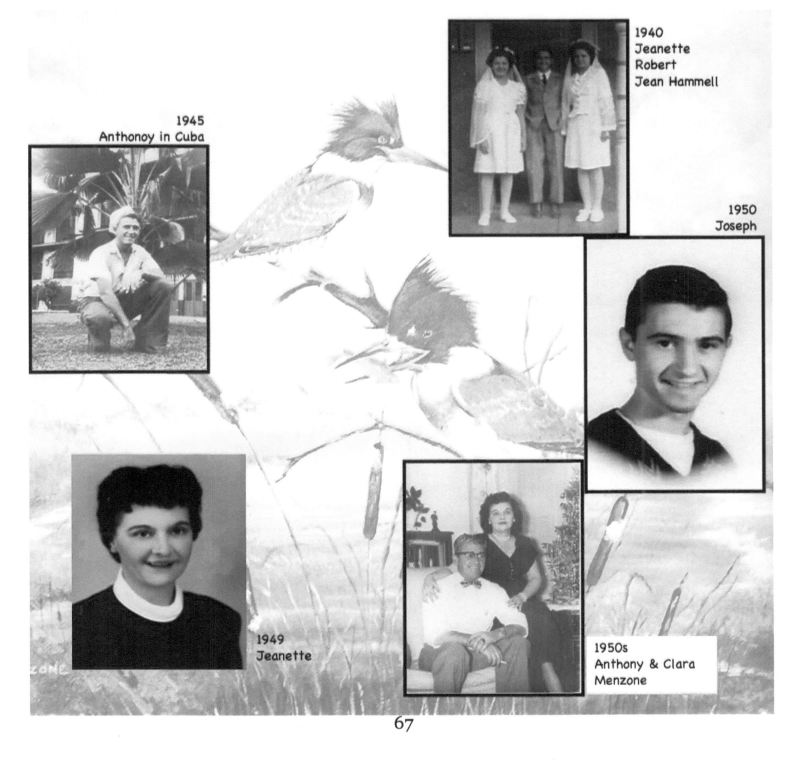

1945
Anthonoy in Cuba

1940
Jeanette
Robert
Jean Hammell

1950
Joseph

1949
Jeanette

1950s
Anthony & Clara
Menzone

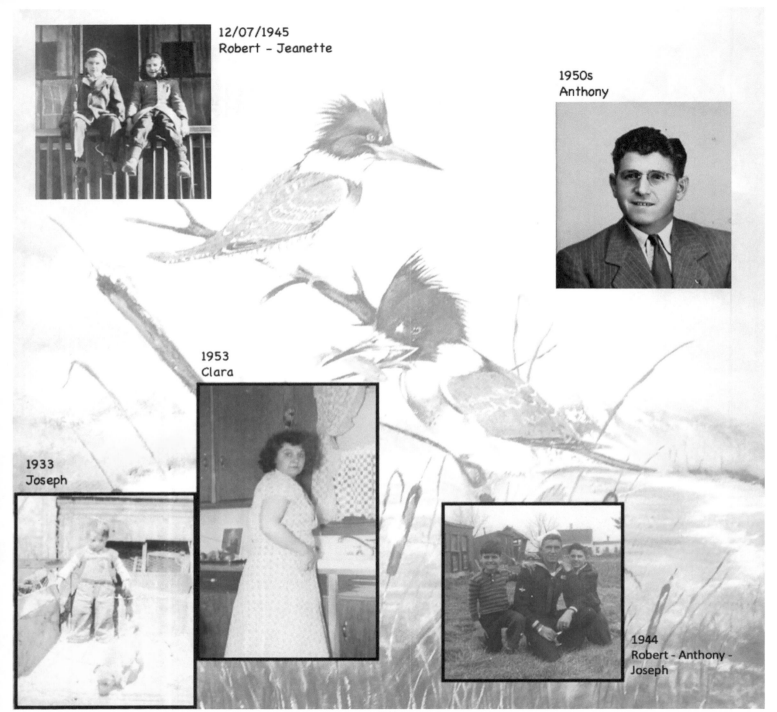

12/07/1945
Robert - Jeanette

1950s
Anthony

1953
Clara

1933
Joseph

1944
Robert - Anthony -
Joseph

The Lapreay-Menzone Family's Life and Love

In 1992, at the time of his death, Anthony Menzone had just welcomed his seventh great-grandchild into the family - Dominic Menzone - to add to his five grandchildren and their spouses, and three children and their spouses.

He believed that anything could be accomplished with hard work and dedication and praised those who were willing to get their hands dirty to solve a problem, create a masterpiece, or better the community.

1946
(rear) Clara - Anthony
(front) Jeanette - Robert - Joseph

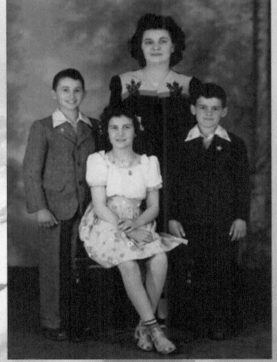

1944
Joseph - Clara - Robert
Jeanette

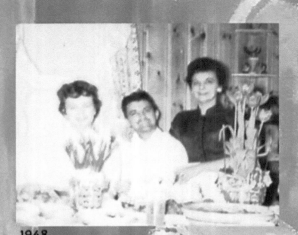

1948
Jeannette - Joseph - Clara

08/1950
Joseph Menzone - Henrietta Lapreay
- Cecilia Lapreay

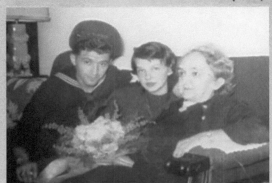

01/08/1987
Clara (Lapreay) Menzone

Clara Menzone

DUDLEY

Clara V. (Lapreay) Menzone, 76, of 11 Ellis St. died this morning at the home of her daughter on Donna Lane.

Mrs. Menzone worked at Anglo Fabric in Webster many years before retiring as an inspector.

She leaves her husband, Anthony Menzone; two sons, Joseph A. and Robert J. Menzone; a daughter, Jeannette, wife of John Laincz, all of Dudley; two brothers, Henry H. Lapreay of Putnam and Adelard Lapreay of Southington, Conn.; three sisters, Blanche E., wife of Wilfred LaPlante of Webster, Pauline, wife of Milton Wilbur of Woonsocket, and Helen Renaurd of North Grosvenor Dale; five grandchildren; three great-grandchildren, nieces, nephews.

She was born in Putnam, a daughter of Joseph and Celia (Cormier) Lapreay, and lived in Dudley many years.

The funeral will be at 9:15 a.m. Saturday from Shaw-Majercik Fu-

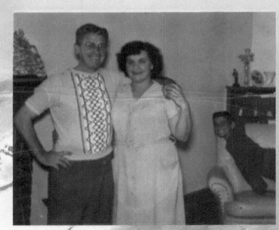

1949
Anthony - Clara - Robert

Lapreay - Menzone Grandchildren

Child	Spouse	Grandchildren	
Joseph	Evelyn (Elliott)	Anthony	Daniel
Jeanette	John Laincz	Donna	
Robert	Lorraine	Michael	Thomas

Michael Menzone

Donna Laincz

Thomas - Michael Menzone

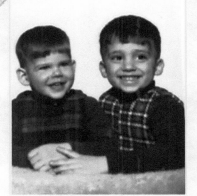

71

11 Ellis Avenue

Anthony Menzone struggled to make ends meet and to provide for his family. One of his proudest moments was when he purchased a large parcel of land in Dudley, Massachusetts, at the end of dead-end street, Ellis Avenue. In 1941, he began construction on the family's home. In 1945, Tony left his home, his wife, and his three children to fight in World War II as part of the United States Navy. He carried pictures of his family with him, but he also carried a picture of his HOME.

1941 – the foundation of 11 Ellis Ave

1945 – 11 Ellis Ave

Joe and Evelyn

I think Marie (Morin) Elliott described Mom and Dad best – Laughter. Sure, they had hard times like everyone else, but they looked for that brighter event. Joe and Evelyn certainly loved each other and they loved their children. Family gatherings always had a "Remember that…" which ended with giggles and a "Yeah, that was stupid" as we dried our eyes from laughing so hard.

One day, Mom's in the kitchen and Dad hollers from the bathroom: "Evelyn, this toothpaste tastes like s---!" Later, Mom is in the bathroom…the "toothpaste" Dad had used, left sitting on the counter, was actually Bengay (a pain-relief cream). Yeah, that was stupid! But, one tube is white with red letters and the other is red with white letters…pretty easy to mix up if you're half asleep!

> *Lots of mothers say they can't wait for their kid to grow up. Not me. I loved my children. I always wanted them to stay little, to stay near me. Every day they showed me something new and I never wanted to give that up.*
>
> *Evelyn Menzone*

Dan Menzone wrote a song for his parents ("Joe and Evelyn," *Menzone Drive*, 2006) that exemplifies the joy and gaiety that surrounded them.

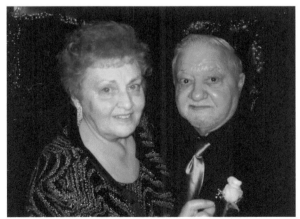

06/10/2010 Evelyn (Elliott) & Joseph Menzone

73

Not Running Away

I was very independent growing up and seemed to cause the most trouble. I didn't like the way the nuns at school treated us, because we were poor and there were so many of us. I left school before graduation. Almost everyone in Willi (Willimantic, CT) worked at American Thread, but I couldn't take the noise of the place and refused to work there. I worked downtown as a soda-jerk. When Joe asked me to marry him, my mother feared that I was trying to run away from her, from the family. She was so upset over my decision to marry that she had to go to a sanctuary for a short time.

I was not running away from my family. I was creating my own family. Some years later, I got sick and had to be hospitalized and then sent home with orders of bed rest. My mother came to stay with us in Dudley, Massachusetts, to help me care for my husband and two children. Before she left, she said to me: *maison est si pleine de rires.*

My home is full of laughter.

Evelyn Menzone

Note: circa 1971 Marie Elliott to Evelyn Menzone

"Dear Child, whatever I can do to separate trouble from my child most in need I would like to do it myself. It is not too huge. Love Mom"

Elliott - Menzone

Family

(1932 –)

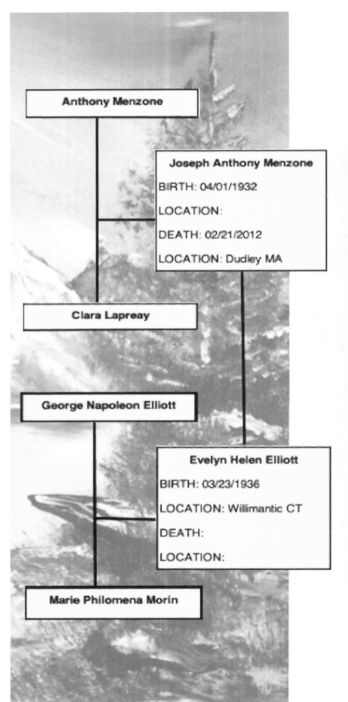

Anthony Menzone

Joseph Anthony Menzone

BIRTH: 04/01/1932

LOCATION:

DEATH: 02/21/2012

LOCATION: Dudley MA

Clara Lapreay

George Napoleon Elliott

Evelyn Helen Elliott

BIRTH: 03/23/1936

LOCATION: Willimantic CT

DEATH:

LOCATION:

Marie Philomena Morin

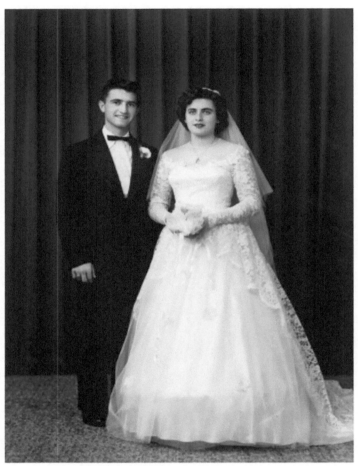

11/27/1954
Joseph & Evelyn Menzone

Wedding Ceremony This Morning In St. Mary's Church

Miss Evelyn Elliott, daughter of Mrs. Marie Elliott of 25 Spruce street, was married to Joseph Anthony Menzone, son of Mr. and Mrs. Anthony Menzone of 11 Ellis avenue, Dudley, Mass. in St. Mary's church this morning at 9 o'clock. The double ring service, for which the bride was given in marriage by the groom's father, was performed by Rev. Roland a Guilmette. Miss Edith Elliott was maid of honor and Francis Baker best man. Miss Jeannette Menzone served as bridesmaid and Raymond Elliott usher.

The bride wore a gown of Chantilly lace over heavy satin fashioned with a fitted bodice, sheer neckline and long tapered sleeves coming to a point at the wrist. Her full bouffant skirt had a nylon tulle adornment and a terminated in a long cathedral train. Her fingertip veil of imported French illusion was fastened to a half hat of lace and satin. She carried a prayer book with an orchid.

The maid of honor wore aqua nylon net, floor length in design and had a bouffant skirt with a lace jacket. She had a half hat of velvet to match the gown and carried a prayer book with shrimp colored carnations.

The bridesmaid was identically to that the maid of honor with her gown being shrimp colored. She carried a prayer book with aqua carnations.

Guests from Dudley, Webster, Boston and Oxford, Mass., Woonsocket, R. I., South Norwalk and this city attended a reception at the Franco-American Civic and Social Club and later in the day when the couple leave on a wedding trip

WEDDING CEREMONY

(Continued From First Page)

the bride will wear a winter white suit trimmed with black velvet and a white feathered hat.

They will reside in Dudley on their return. The groom, a graduate of Dudley Junior High school and Bartlett High school in Webster is employed in Dudley. The bride is a former student of St. Mary Parochial school.

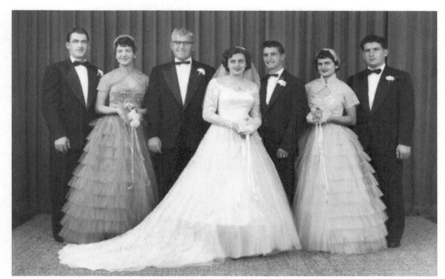

Raymond Elliott – Jeannette Menzone – Anthony Mensone – Evelyn & Joseph Menzone – Edith Elliott – Francis Baker

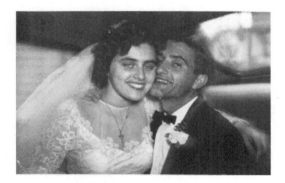

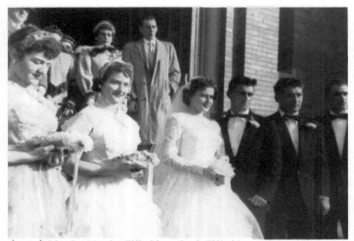

(rear) Marie Morin Elliott - Carl Elliott
(front) Jeanette Menzone - Edith Elliott - Evelyn &
Joseph Menzone - Francis Baker - Raymond Elliott

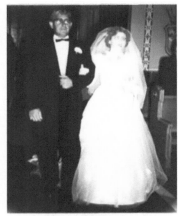

Anthony Menzone as
"Father of the Bride"
- Evelyn Elliott

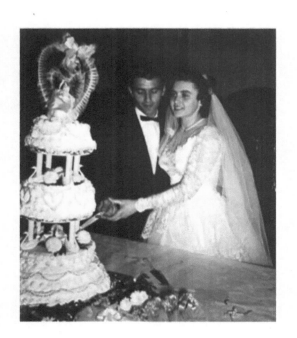

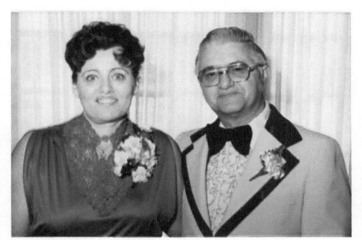

01/10/1981

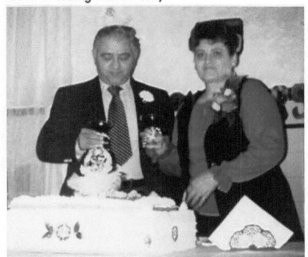

11/27/1979
25th Wedding Anniversary

10/15/1993

79

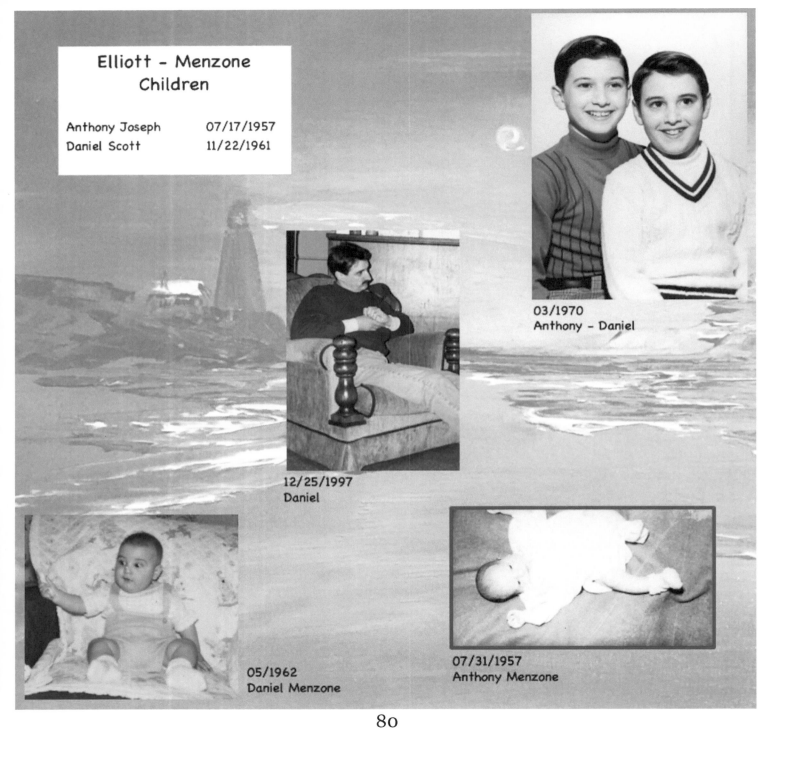

Elliott - Menzone
Children

Anthony Joseph	07/17/1957
Daniel Scott	11/22/1961

03/1970
Anthony - Daniel

12/25/1997
Daniel

05/1962
Daniel Menzone

07/31/1957
Anthony Menzone

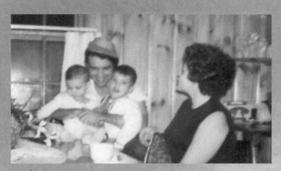

03/1962
Daniel - Joseph - Anthony - Clara

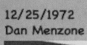

12/25/1972
Dan Menzone

06/1997
Anthony

02/1999
Daniel

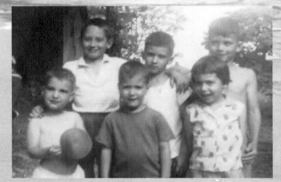

09/1964
(rear) Mical Matassa - Anthony Menzone
- Mark Baronousky
(front) Daniel Menzone - James Matassa
- Karen Matassa

81

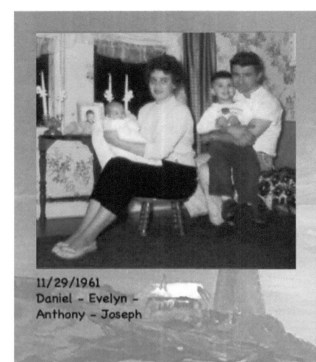

11/29/1961
Daniel - Evelyn -
Anthony - Joseph

12/1983
Daniel

09/1957
Anthony

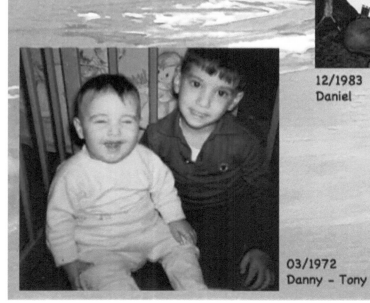

03/1972
Danny - Tony

1975
Anthony

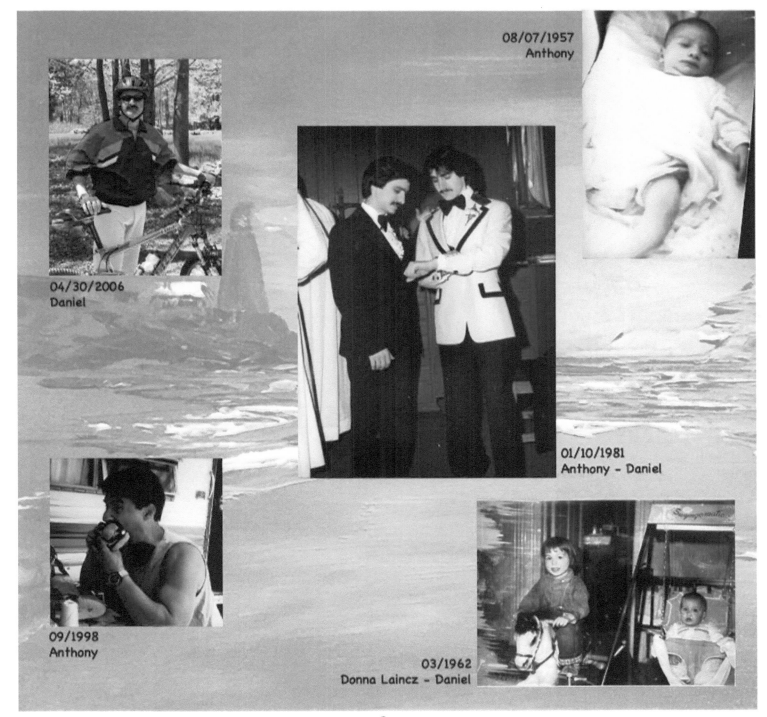

08/07/1957
Anthony

04/30/2006
Daniel

01/10/1981
Anthony - Daniel

09/1998
Anthony

03/1962
Donna Laincz - Daniel

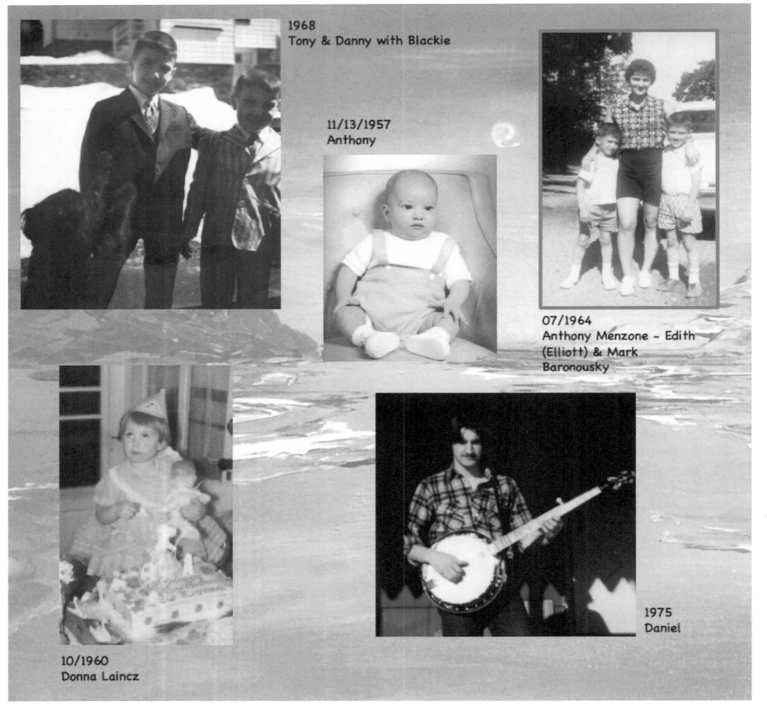

1968
Tony & Danny with Blackie

11/13/1957
Anthony

07/1964
Anthony Menzone - Edith
(Elliott) & Mark
Baronousky

10/1960
Donna Laincz

1975
Daniel

84

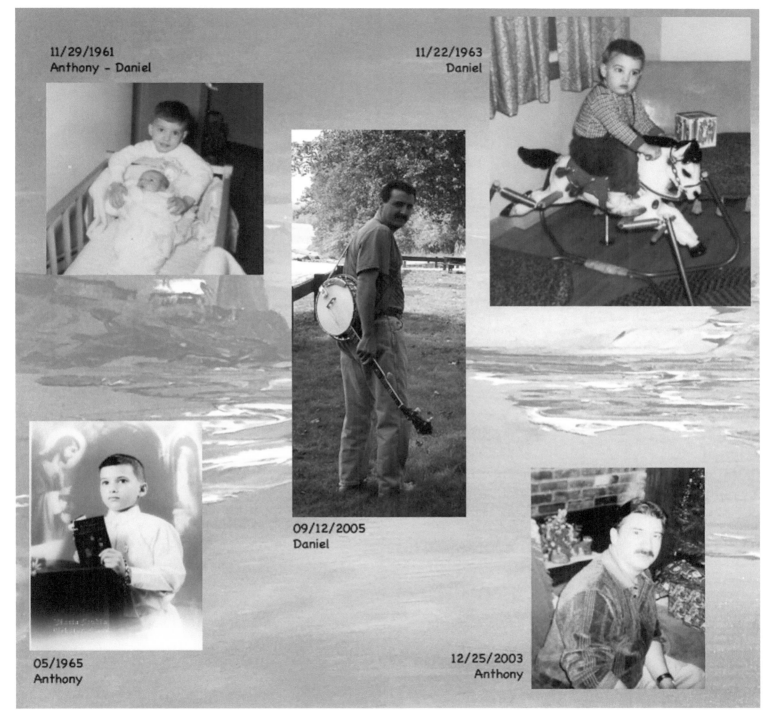

11/29/1961
Anthony - Daniel

11/22/1963
Daniel

09/12/2005
Daniel

05/1965
Anthony

12/25/2003
Anthony

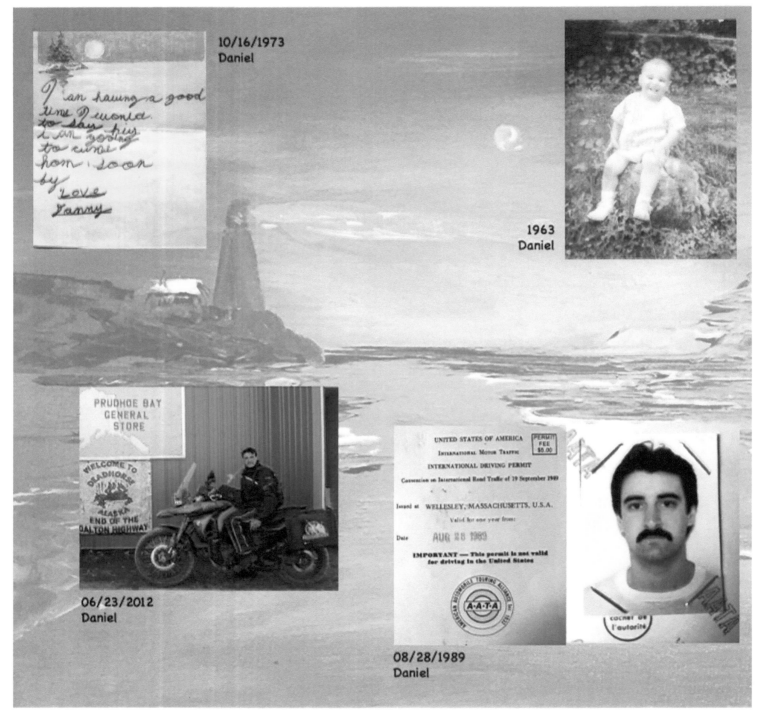

10/16/1973
Daniel

I am having a good
time I would
to say hi
I am going
to come
home soon
by
Love
Danny

1963
Daniel

PRUDHOE BAY
GENERAL
STORE

WELCOME TO
DEADHORSE
ALASKA
END OF THE
DALTON HIGHWAY

06/23/2012
Daniel

UNITED STATES OF AMERICA
INTERNATIONAL MOTOR TRAFFIC
INTERNATIONAL DRIVING PERMIT
Convention on International Road Traffic of 19 September 1949

Issued at WELLESLEY, MASSACHUSETTS, U.S.A.
Valid for one year from:
Date AUG 28 1989

IMPORTANT — This permit is not valid
for driving in the United States

08/28/1989
Daniel

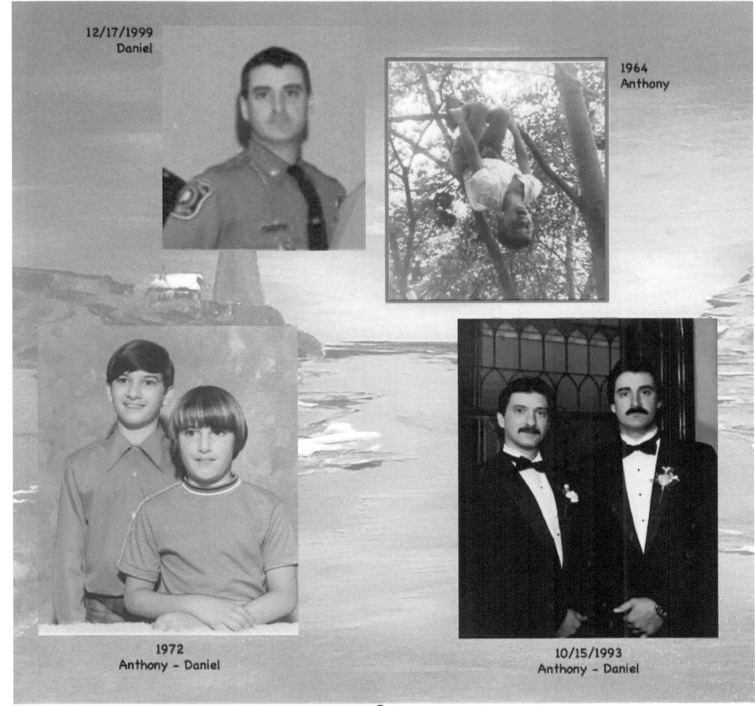

12/17/1999
Daniel

1964
Anthony

1972
Anthony - Daniel

10/15/1993
Anthony - Daniel

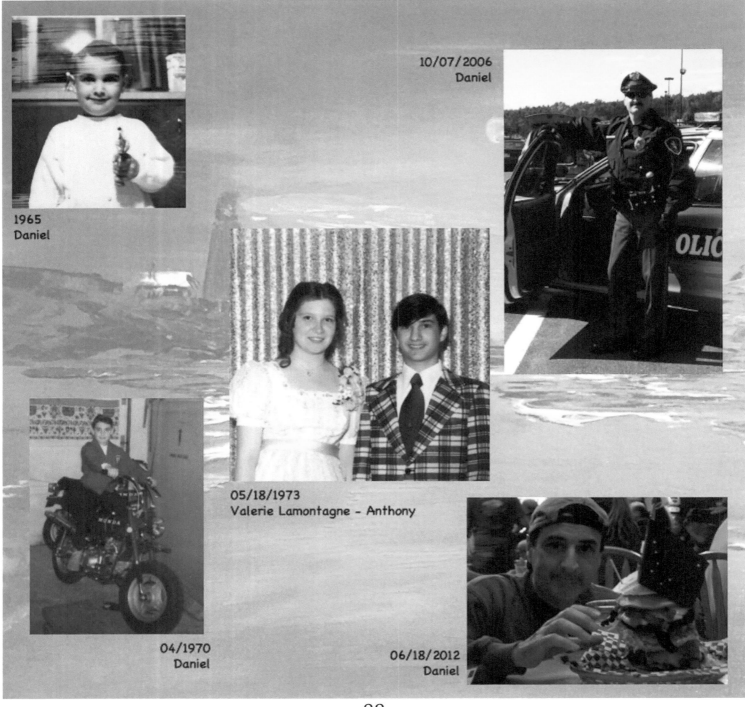

1965
Daniel

10/07/2006
Daniel

05/18/1973
Valerie Lamontagne - Anthony

04/1970
Daniel

06/18/2012
Daniel

88

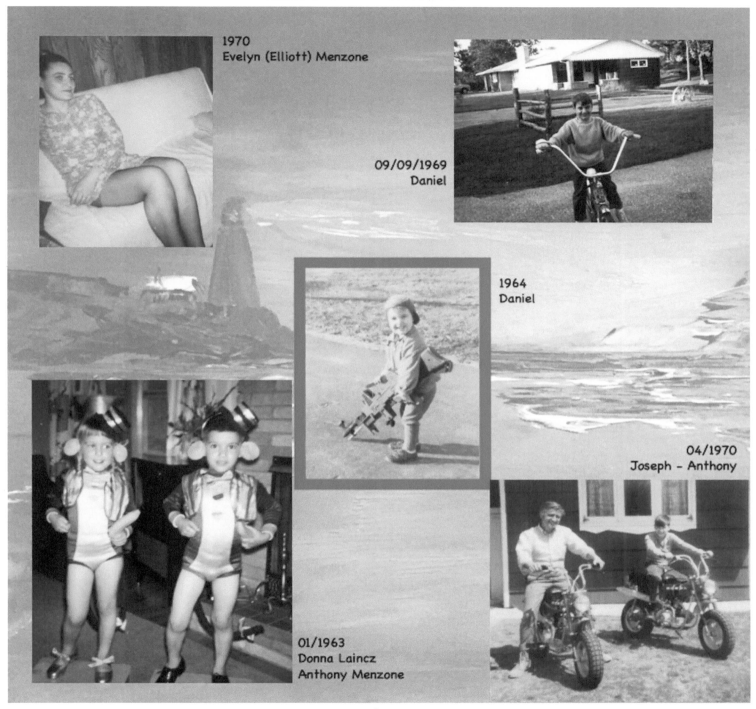

1970
Evelyn (Elliott) Menzone

09/09/1969
Daniel

1964
Daniel

04/1970
Joseph - Anthony

01/1963
Donna Laincz
Anthony Menzone

12/1968
Daniel - Anthony - Joseph

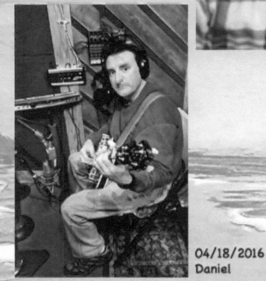

04/18/2016
Daniel

1965
Anthony - Daniel

1965
Daniel - Donna Laincz - Wayne Lester
- Anthony - Mical Matassa

06/08/1975
Robert Menzone - Anthony - Doris Elliott

08/1968
Daniel - Anthony

1975
Lorraine & Robert
Menzone
Evelyn - Anthony -
Michael Menzone

10/15/1993
Anthony - Daniel

04/1970
Daniel

11/22/1969
Michael Menzone -
Daniel - Donna Laincz
- Anthony - Tommy
Menzone

The Elliott-Menzone Family's Life and Love

Joseph Menzone worked in Sheet Metal Worker's Union, Local 63, after serving in the US Navy during the Korean War. When he passed away on February 21, 2012, he had two children, three grandchildren, and a grand-daughter-in-law.

05/2004
Daniel - Joseph

92

06/08/1975
Clara - Joseph - Anthony - Daniel - Evelyn (Elliott)
Menzone - Marie (Morin) Elliott

11/28/1957
Joseph Menzone - Clara Menzone
Anthony Menzone - Cecelia Lapreay

07/1996
Joseph - Evelyn

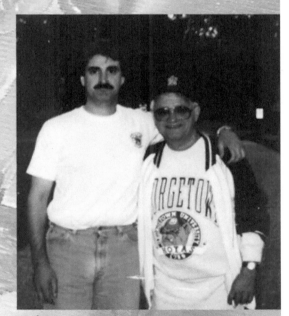

04/1993
Daniel - Joseph

93

05/2003
Joseph - Anthony

11/28/1957
Joseph - Anthony - Anthony

08/25/2000
Joseph - Daniel - Evelyn

07/1958
Jeannette (Menzone) Laincz -
Anthony - Clara - John Laincz

94

06/1994
Anthony & MaryEllen - Melissa & Daniel

05/28/2006
Evelyn - Joseph

12/25/2010
Joseph - Evelyn

95

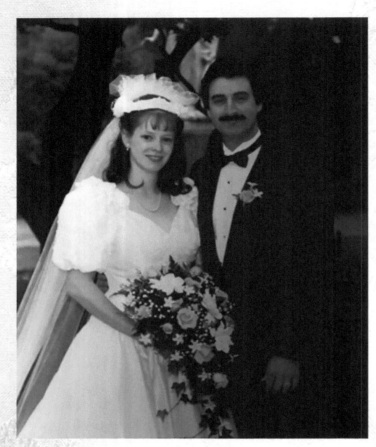

10/15/1993
Melissa (Ladyka) & Daniel Menzone

Evelyn & Joseph - Marie Elliott
(background - Gary Cummings & wife (friends))

Joel Ladyka - Melissa Ladyka

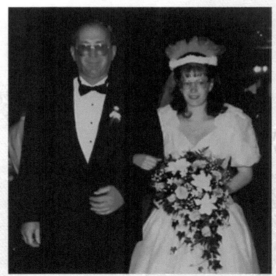

Katherine (Ladyka) Brodeur - Lisa Menzone
- MaryEllen Menzone - Melissa Menzone
Daniel Menzone - Anthony Menzone -
Michael Ladyka
(front) Joseph Menzone - Christopher
Brodeur

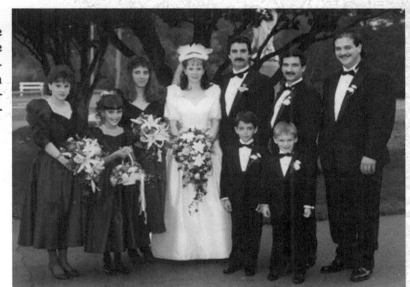

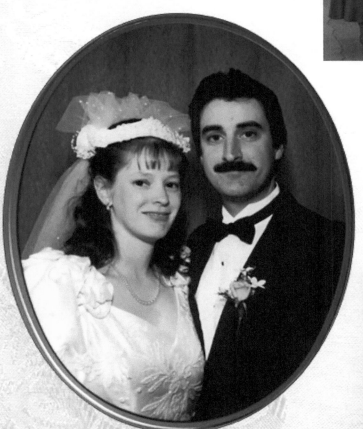

Anthony - Melissa - Daniel - Marie - Evelyn - Joseph

97

3 Menzone Drive

It is an understatement to say that family is important and that we want to feel close with one another. Anthony and Clara (Lapreay) Menzone felt so strongly about having their children, Joseph, Jeanette, and Robert, near that Anthony purchased enough land to create a haven for his children and grandchildren. In 1962, Anthony and Joseph broke the ground at what was to become our home, our place for family unity: 3 Menzone Drive. In later years, Robert built his home at 7 Menzone Drive and then Donna Lane was added for Jeanette and her family.

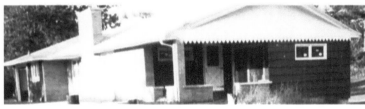

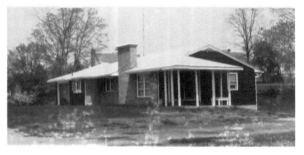

(top) September 1969
(bottom) October 1962

Admittedly, sometimes having the three siblings and their parents in such close proximity prolonged ordinary bickering. Even so, growing at Menzone Drive was special. And as our family grew from just Anthony and Daniel to their spouses and children, 3 Menzone Drive became "Our Place" to convene, to relate, to debate, to honor, to support, and to just be ourselves.

Dad (Joseph Menzone) always said only death would make him leave Menzone Drive and on February 21, 2012, he received that wish. The last all-encompassing family gathering at 3 Menzone Drive was for Dad's funeral.

School is for Play

Daniel Menzone attended boarding school between June 1972 and June 1977 and during part of that time he was a member of the school's tennis team. As he departed the bus at one match, he'd discovered that, somehow, he'd managed to forget his tennis shoes. Rather than "hang up the towel," he strode onto the court, racket in hand, wearing his army boots. He remembers it as the worst day for his feet, but a great day because he won the match. Oh, yes, people laughed...but he had the Victory! Too bad I don't have a picture (or a movie!) of that spectacular feat.

I was in a study period, in the cafeteria, when Henry appears in the doorway and signals to me. For some reason, he'd showed up at school on a horse. This was wintertime, it was cold, and he wanted to get a coffee. Having nothing better to do, I went outside and hopped on the horse. Later, while walking down the hall, Principle Thibodeaux stopped me: "Mr. Menzone, is it my imagination or did you gallop by my office on a horse?" I looked him in the eye, shrugged, and replied: "Yeah, that was me."

Dan Menzone

1975 Anthony Menzone

Riding a horse around the school property is one thing...but what about riding a motorcycle inside the school? I don't recommend this, children.

10/15/1994 Lisa Menzone 1st Wedding Anniversary Card

1960's Learn to Spell puzzles

McGee - Menzone

Family

(1981 -)

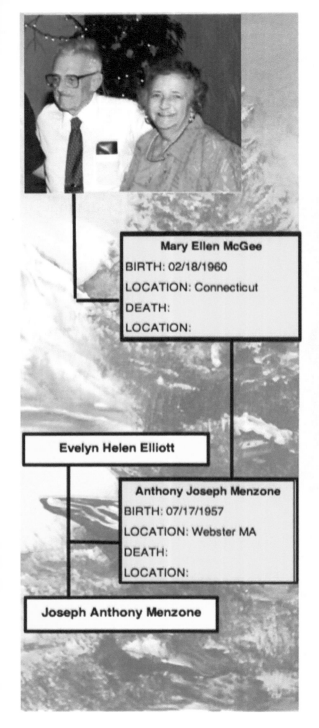

MaryEllen McGee is the daughter of Donald & Claire (Guerin) McGee. She was raised in Quinebaug, Connecticut. This picture of her parents was taken 06/26/2010.

Mary Ellen McGee
BIRTH: 02/18/1960
LOCATION: Connecticut
DEATH:
LOCATION:

Evelyn Helen Elliott

Anthony Joseph Menzone
BIRTH: 07/17/1957
LOCATION: Webster MA
DEATH:
LOCATION:

Joseph Anthony Menzone

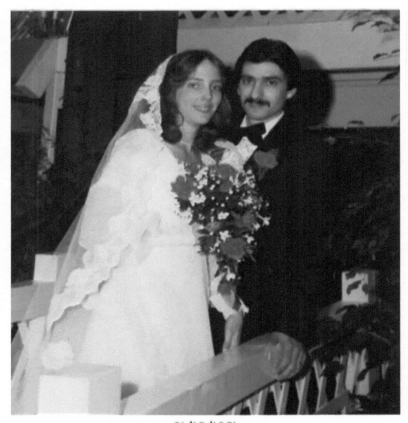

01/10/1981
MaryEllen (McGee) & Anthony Menzone

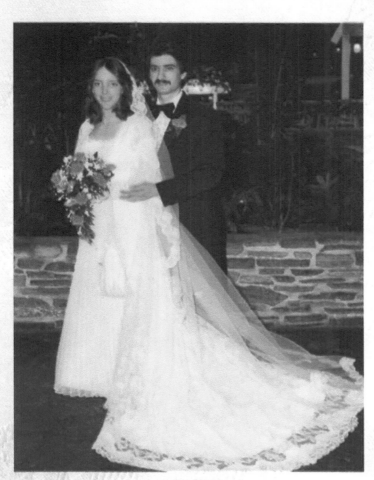

01/10/1981
Maryellen (McGee) & Anthony Menzone

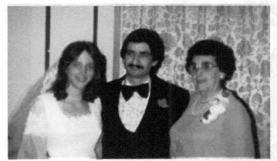

MaryEllen - Anthony - Marie Elliott

MaryEllen McGee - Don McGee

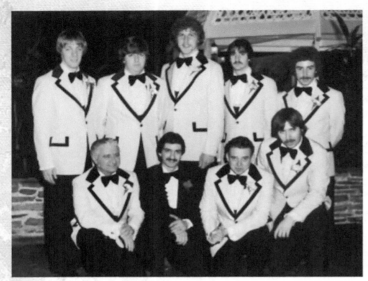

(rear) Peter Rooney – Michael McGee – David Gall – Daniel Menzone – Tom McGee
(front) Joseph Menzone – Anthony Menzone – Don McGee – Donny McGee

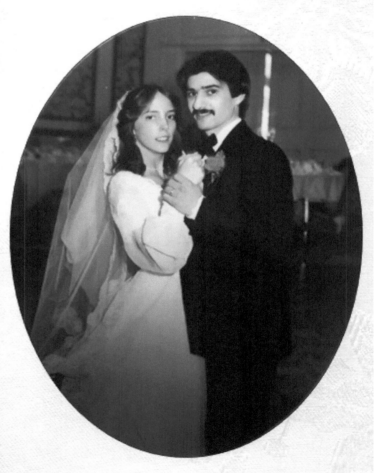

Clara – MaryEllen – Anthony – Anthony

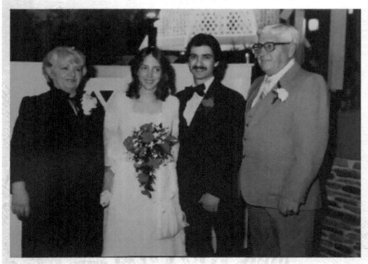

104

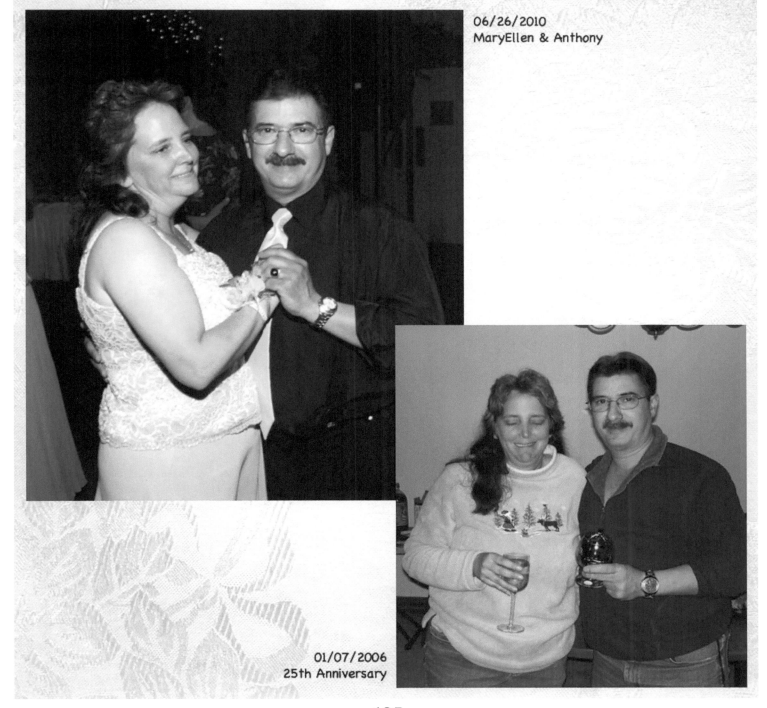

06/26/2010
MaryEllen & Anthony

01/07/2006
25th Anniversary

105

McGee-Menzone
Children

Lisa	04/25/1983
Joseph	11/21/1985
Dominic	10/22/1992

04/1983
Lisa

06/1994
Dominic

1995
Dominic

1988
Christopher Brodeur - Lisa - Joseph

06/2003
Evelyn - Lisa - Joseph

08/1993
Melissa & Daniel
Dominic - Lisa

04/1993
Lisa - Daniel

06/1997
Joseph

06/26/2010
(rear) Evelyn (Elliott)- Shirley Elliott - Edith (Elliott)
Baronousky - Joseph - Lisa
(front) Joseph - Janet (Elliot) Matassa

06/18/2006
Joseph

1989
Joseph - Edith
(Elliott) Baronousky

10/24/1992
Dominic - Lisa

05/28/2006
Lisa

07/1993
Evelyn - Dominic

108

07/04/1997
Joseph - Evelyn - Dominic - Joseph -
MaryEllen - Anthony - Lisa

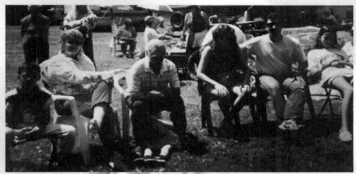

11/21/1985
Joseph

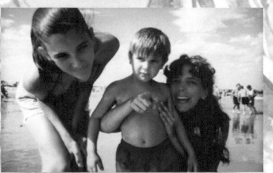

07/08/1997
Lisa - Dominic - Maryellen

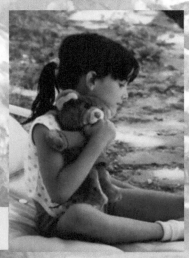

06/1991
Lisa

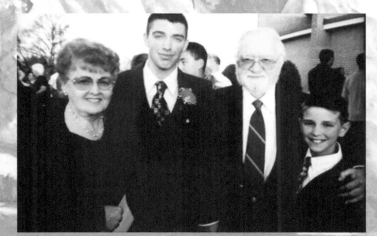

06/2003
Evelyn - Joseph - Joseph - Dominic

10/22/1992
Dominic

06/1987
Evelyn - Lisa- Joseph

06/2003
Daniel - Joseph - Melissa

02/1998
MaryEllen - Daniel - Melissa

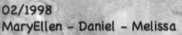

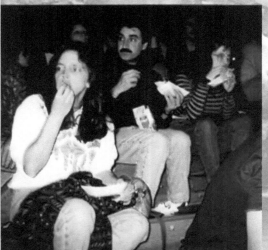

1997
Lisa - Joseph - Dominic

110

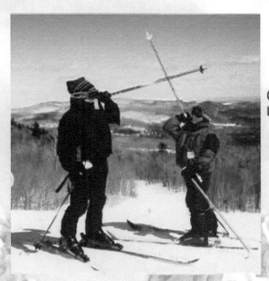

02/1997
Lisa – Joseph

10/22/1992
Evelyn – MaryEllen
Dominic

1989
Lisa – Joseph

01/04/2013
Joseph – Evelyn

02/1993
Joseph – Dominic – Lisa

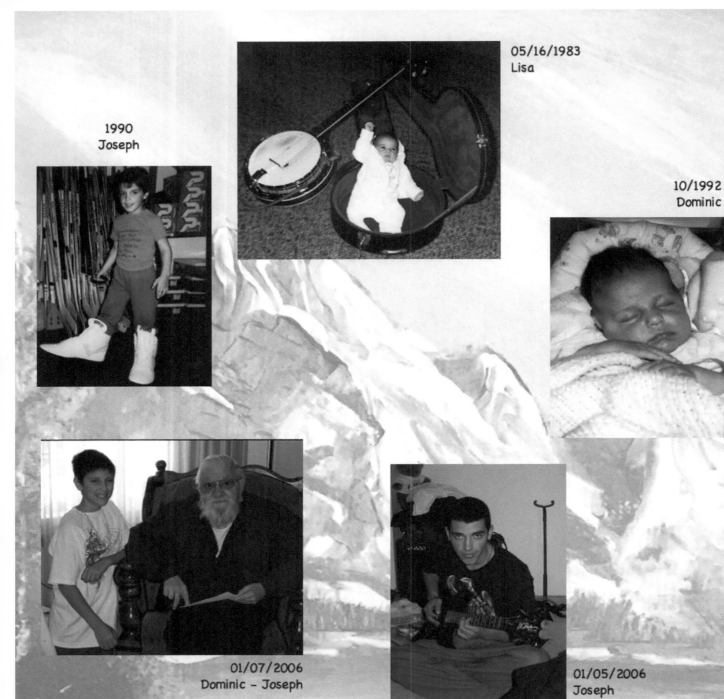

05/16/1983
Lisa

1990
Joseph

10/1992
Dominic

01/07/2006
Dominic – Joseph

01/05/2006
Joseph

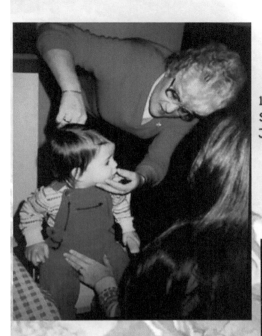

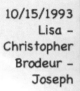
10/15/1993
Lisa –
Christopher
Brodeur –
Joseph

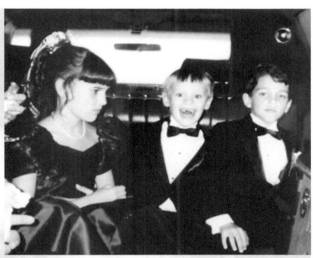

1986
Shirley Elliott –
Joseph

11/05/2006
Anthony – Joseph –
Dominic – Daniel

04/1986
Lisa – Clara (Lapreay)

06/1997
Lisa – Joseph

113

1986
Lisa - Joseph

04/1994
Anthony - Joseph

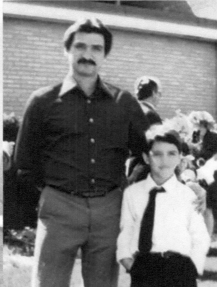

1990
Lisa

1987
Lisa - Daniel

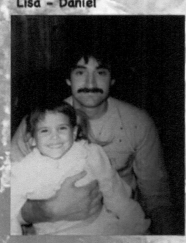

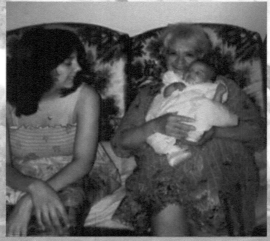
04/1983
MaryEllen - Clara (Lapreay) - Lisa

1987
Joseph

06/2003
MaryEllen - Joseph - Lisa -
Anthony - Evelyn - Melissa

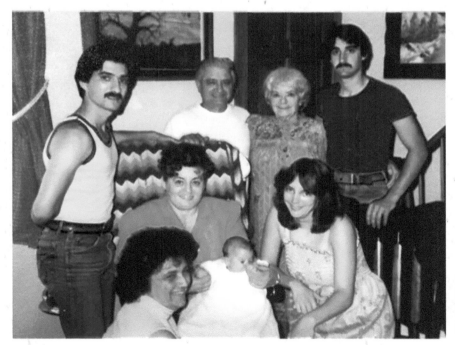

04/1983
(rear) Anthony - Joseph - Clara - Daniel
(center) Evelyn - MaryEllen (McGee)
(front) Claire (McGee) - Lisa

08/1983
Joseph - Anthony -
Lisa - MaryEllen -
Evelyn

10/15/1993
Maryellen - Anthony
Joseph - Lisa

04/1994
Joseph - Evelyn - Dominic
Joseph

116

04/1994
(rear) Melissa - Lisa - Daniel
(front) Evelyn - Joseph - Edith
(Elliott) Baronousky - Joseph

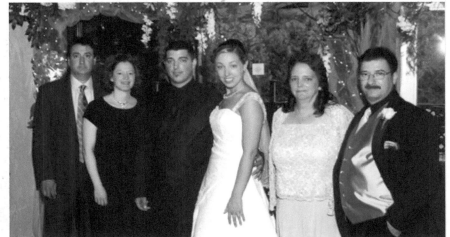

06/26/2010
Daniel & Melissa - Joseph & Jessica - MaryEllen & Anthony

09/1998
Anthony - MaryEllen - Dominic - Lisa

117

04/1994
(rear) Maryellen (McGee) - Claire & Don McGee
(front) Joseph - Lisa

07/2006
Joseph - Lisa - Dominic
Anthony - MaryEllen

09/1998
Dominic - Lisa - Joseph - MaryEllen

118

Jessica (Johnson) & Joseph Menzone

Lisa Menzone & Jay Wykes

119

08/2018
Jay Wykes – Aiden Wykes –
Lisa Menzone

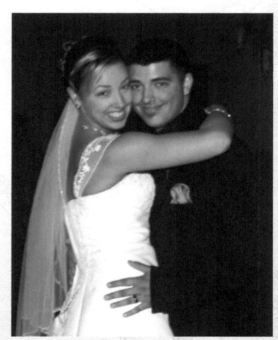

06/26/2010
Jessica (Johnson) & Joseph Menzone

120

McGee - Menzone Grandchildren

Child	Spouse	Grandchildren	
Lisa	Jay Wykes	Josselin	
Joseph	Jessica (Johnson)	Oakley	Aria
Dominic			

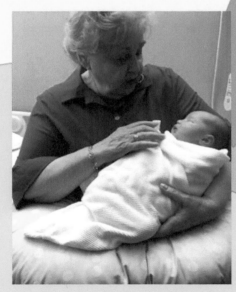

03/18/2015
Evelyn (Elliott) Menzone –
Oakley Menzone

11/15/2018
Evelyn – Josselin Wykes

08/20/2017
Evelyn – Aria Menzone

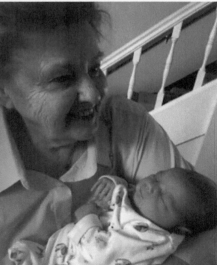

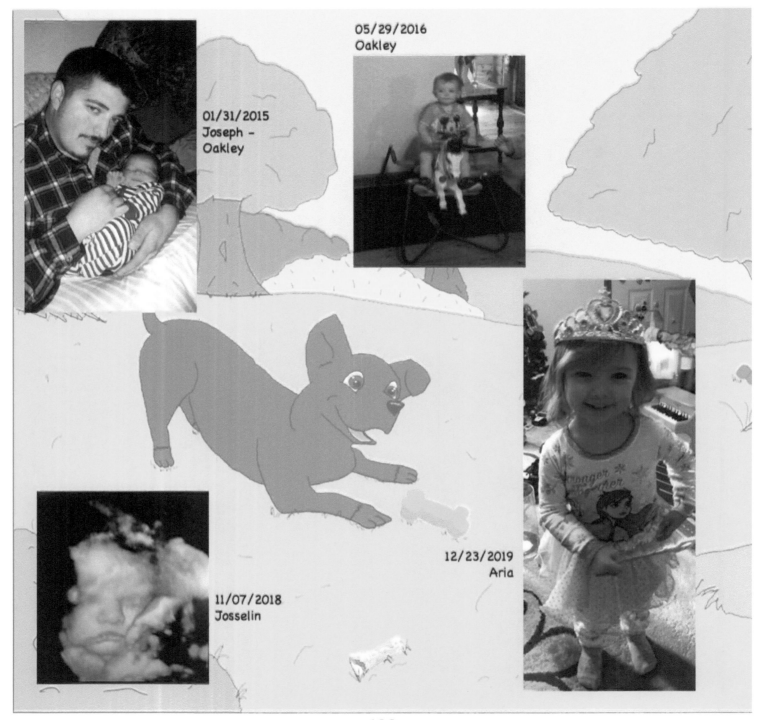

01/31/2015
Joseph –
Oakley

05/29/2016
Oakley

11/07/2018
Josselin

12/23/2019
Aria

122

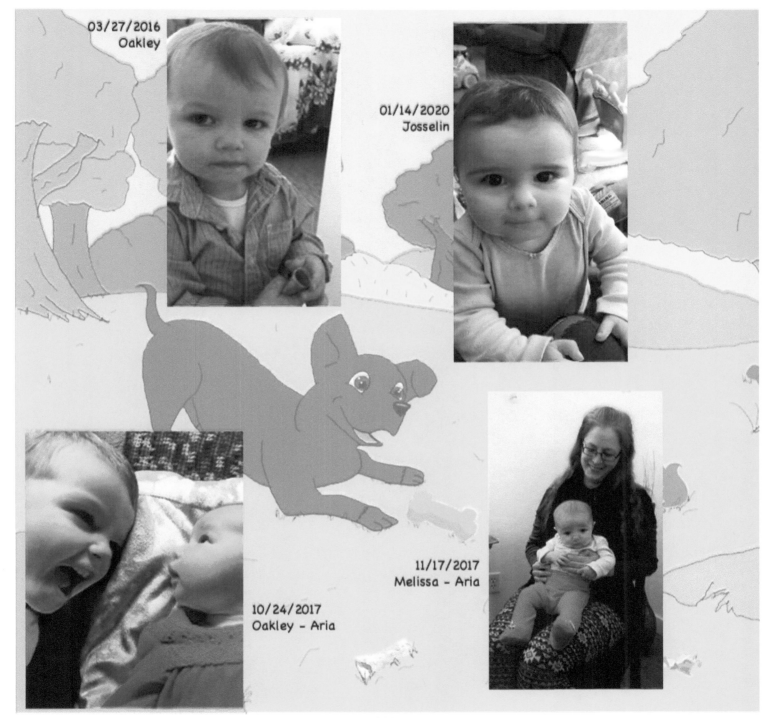

03/27/2016
Oakley

01/14/2020
Josselin

10/24/2017
Oakley - Aria

11/17/2017
Melissa - Aria

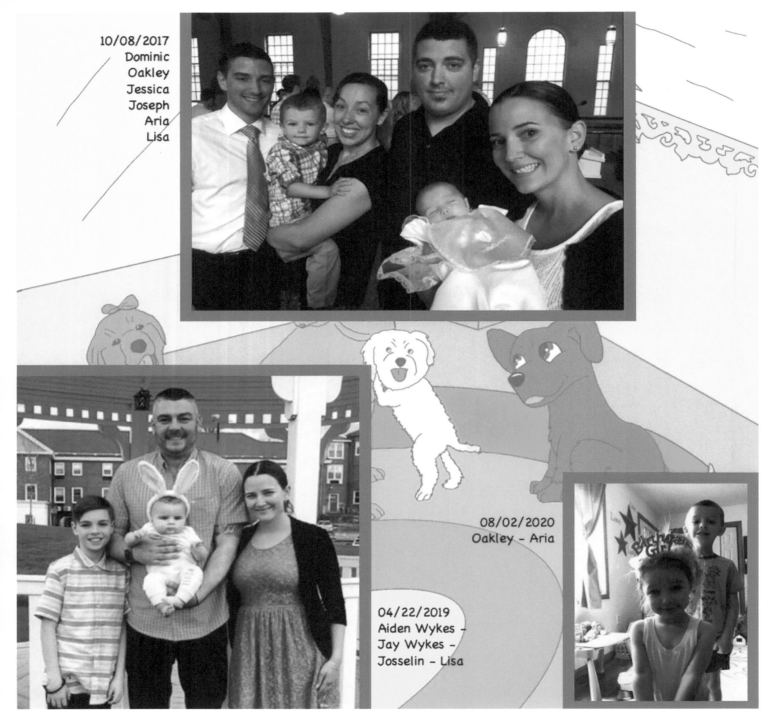

10/08/2017
Dominic
Oakley
Jessica
Joseph
Aria
Lisa

08/02/2020
Oakley - Aria

04/22/2019
Aiden Wykes -
Jay Wykes -
Josselin - Lisa

124

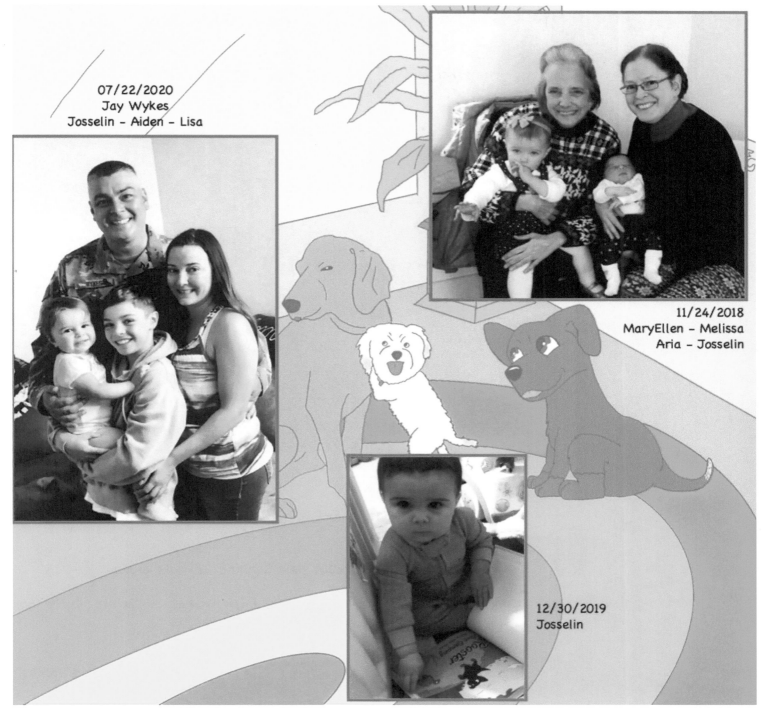

07/22/2020
Jay Wykes
Josselin - Aiden - Lisa

11/24/2018
MaryEllen - Melissa
Aria - Josselin

12/30/2019
Josselin

125

AUTOGRAPHS

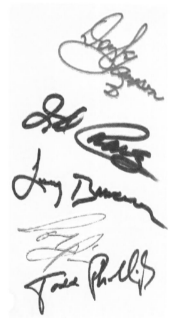

GRAND OLD OPRY CURLY FOX "WORLD CHAMPION FIDDLER"

Top Left: 05/25/2001 New England Patriots alumni

Top Right: "To Doris with best wishes Sincerely Curly Fox 9/19/76" - Presented to Doris Elliott

Bottom: The Bluegrass Album Band, 1982
Doyle Lawson, JD Crowe, Terry Baucom, Tony Rice, Todd Philips

Our Creative Side

Marie Morin Elliott was very talented. At a young age, she had learned how to sew, which was common among people living in small, rugged and rural towns. Throughout her Willimantic home, she had handmade blankets, quilts, pillow shams, and doilies. The Morin-Elliott children used to collect "sack cloth" from local stores (cloth for flour and grain bags) and Marie boiled, bleached, and sun-dried the fabric for use in sewing. Through the 1940s, most of the clothing, including jackets, worn by Marie and her children had come from her hand. Examples are prevalent in the photos particularly all of the Morin-Elliott family's first communion dresses.

> She would pull apart a dress, a shirt, or a blanket in the evening and in the morning, we had a new dress.
>
> Evelyn Menzone

She was also skilled in embroidery as well as "Tatting" – a technique for handcrafting lace from a series of knots and loops. Unfortunately, the skill of tatting itself has not been preserved through our family; however, many beautiful examples of Marie's efforts remain, including this piece of lace which once graced the top of a handsewn nightgown that Marie made (and wore) in 1917.

It is said that Marie could bake a cake in a cast iron pan on the stovetop and that she had a knack for making a little bit of food seem like a feast. I asked her once for a thin slice of cake – without thought, she handed me a slice thinner than a piece of paper.

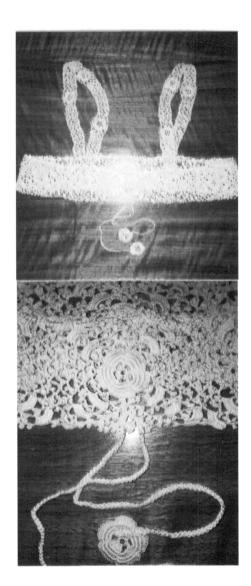

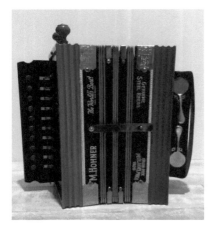

My mother had a beautiful voice. Her whole family sang or played an instrument. She wrote all of her own music.

Evelyn Menzone

Unfortunately, any written lyrics or compositions created by Marie have been lost to time. Music, however, runs through both lines of the Elliott-Menzone family, from fife and drum to piano and bugle to guitar and banjo. We are honored to have an award winning, nationally and internationally recognized, musician in the family: Dan Menzone! Some of his accomplishments include being the banjoist for the first Bluegrass band on Danish television, playing on the internationally acclaimed stage "The Hatch" in Boston, taking first place in the 2010 International Songwriting Competition, and being named among the top ten banjoists in Europe. He's played on stage alongside JD Crowe and the Osborne Brothers, as well as shared billing for stages and events with Emmy-Lou Harris, Ricky Skaggs, Tony Rice, and Earl Scruggs.

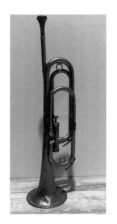

Included here are photos of family relics: a 1940s horn and a 1926 diatonic button accordion. It is unclear who might have played them in the past. Joseph Menzone played the fife, of which we have a couple, but they are not photogenic, and drums as indicated in his 1950 US Navy record.

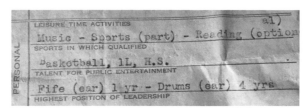

Several family members had a skill at drawing; others simply put their heart onto paper which takes courage and for that we are ever grateful. I have essays and short stories, letters, notes, and doodle art saved over the years from many of our relatives. Unfortunately, only the shortest of these made it into this pictorial.

Our family's talent also has a competitive side. Anyone who knew Joseph Menzone also knew he loved sports, but few knew he played on his junior-high school basketball team. He was also an avid swimmer and competed while in the Navy. His granddaughter, Lisa Menzone, was also

on a swim team as a child. In March 2021, his great-granddaughter, Josselin Wykes (2yo), had her first swim lesson and Aria Menzone (4yo) has started gymnastics.

Some skills are more about endurance than creativity, but nevertheless, they lead to personal accomplishments although they often remain as hobbies such as cycling, karate, and motocross. Joseph Menzone held a pilot's license and owned a single-engine plane in the early-mid 1960s. Others took their special interests and evolved them into careers, such as Dan Menzone becoming a Law Enforcement Tactical Firearms Instructor or Joseph Menzone's masonry work, most notably seen in his construction of the fireplace at The Lodge, Webster, Massachusetts. Below is stonework built (circa 2002) by Melissa Menzone with the help of Joseph and Dan Menzone.

Creativity is a passion that we shouldn't set aside. Be inspired and give something of yourself to the world.

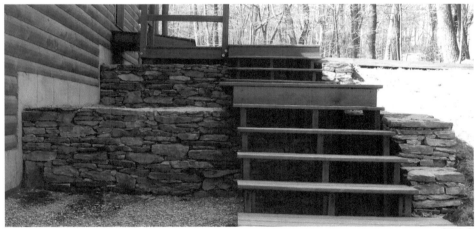

2002
78 Potter Village Road, Charlton, MA

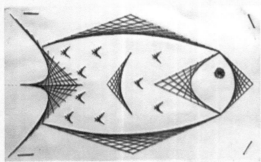

1972
Needle work isn't just for
women! Anthony Menzone
(15 yo)

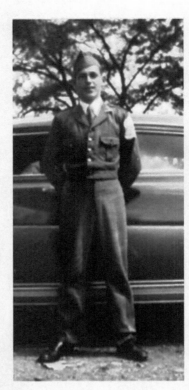

1950
Carl Elliott
St. Mary's
School Drum
Corp

10/1993
Joseph Menzone (8 yo)
Wedding gift for Uncle Dan & Aunt Missy

1970
Joseph Menzone building
a fireplace at
The Lodge, Webster MA

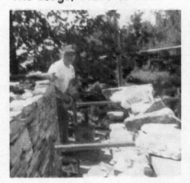

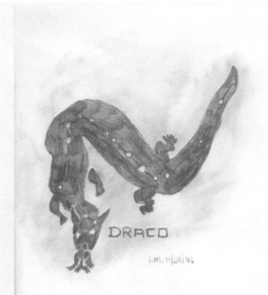

11/28/1996
Lisa Menzone
"Draco" pencil drawing

2018
Daniel Menzone
On Stage

1973
Daniel Menzone
Tile Chip Art

1971
Anthony Menzone (14 yo)
Get Well card for brother Danny

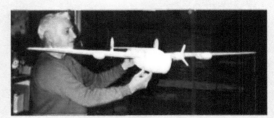

02/1996
Joseph Menzone
Model airplane

04/1996
Joseph Menzone
"The Desk"

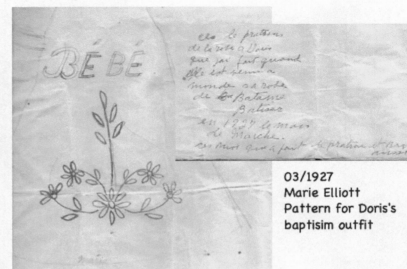

03/1927
Marie Elliott
Pattern for Doris's
baptisim outfit

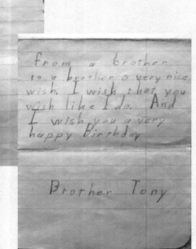

11/22/1966
Anthony Menzone
Birthday card for
brother Danny

1977
Melissa (Ladyka) Menzone
Horse quilt

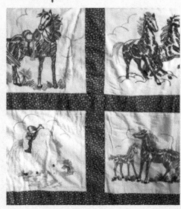

1929
Marie (Morin) Elliott
Baby Dress

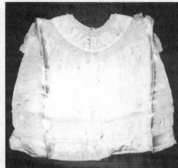

1966
Daniel Menzone
Kindergarten drawing

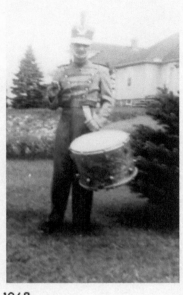

1948
Joseph Menzone
Dudley Junior High
Marching Drum Band

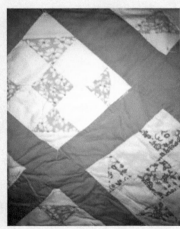

1940s
Marie (Morin) Elliott
Patch quilt

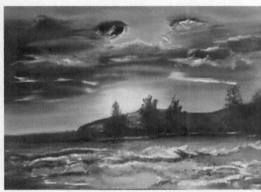

1985
Joseph Menzone (53 yo)
Lake Sunset

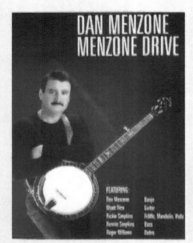

2006
Daniel Menzone

1929
Marie (Morin) Elliott
Baptisim outfit for Ray

1967
Anthony Menzone (10 yo)
Invitation to mom and dad

1980s
Joseph Menzone

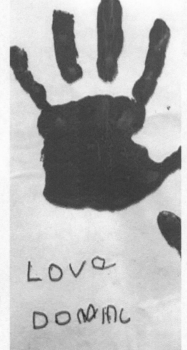

1999
Dominic Menzone

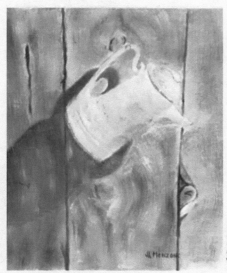

1982
Joseph Menzone

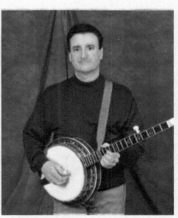

2010
Daniel Menzone
1st Place Instrumental Winner
"Gone Bezerk"

2016
Daniel Menzone
Record Label & #1 Album

1940s
Marie (Morin) Elliott
Quilt

1965
Daniel Menzone

05/1962
Anthony Menzone

07/1994
Joseph Menzone

SPORT ★ STARS

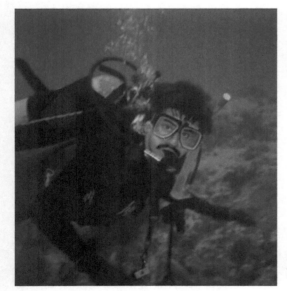

10/1991
Daniel Menzone

136

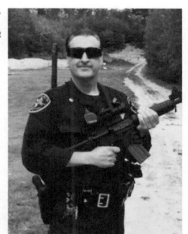

09/22/2017
Daniel Menzone

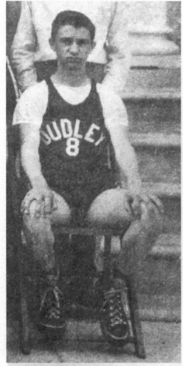

1947-48 Dudley Junior High Basketball Team

1947
Joseph Menzone

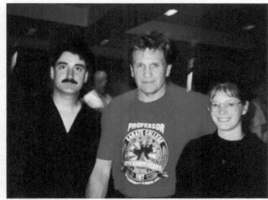

1997
Dan Menzone – Joe Lewis –
Melissa Menzone
Century Martial Arts Seminar

02/1998
Lisa – Tony –
Joseph – MaryEllen
Karate Competition

1964
Joseph Menzone

02/1999
Lisa Menzone
Joseph Menzone

08/27/2010
Daniel Menzone

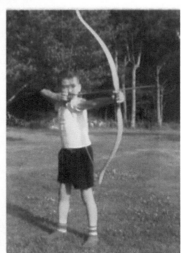

1965
Anthony Menzone

138

An Honor to Protect and Serve

I am proud to say that six generations of the Elliott-Menzone family have held an ingrained duty to protect those less fortunate. Our family had and still has members of the military, law enforcement, religious vocations, politics, and the medical community. Each of these men and women held, and continue to hold, themselves out to public scrutiny in favor of making a difference to their community, their country, and the world at large.

> *Aunt Jenny [Eugenie Morin Cadotte] was a wonderful person, a kind woman. She used her own money to start a church in the Philippines. She devoted her life to paying penance for her sins.*

<div align="right">Edith Baronousky</div>

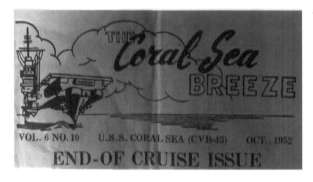

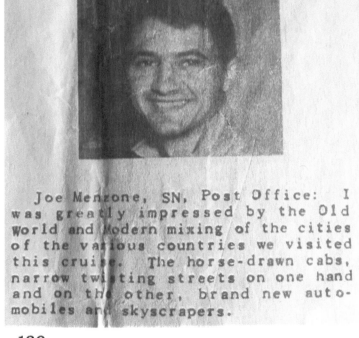

Joe Menzone, SN, Post Office: I was greatly impressed by the Old World and Modern mixing of the cities of the various countries we visited this cruise. The horse-drawn cabs, narrow twisting streets on one hand and on the other, brand new automobiles and skyscrapers.

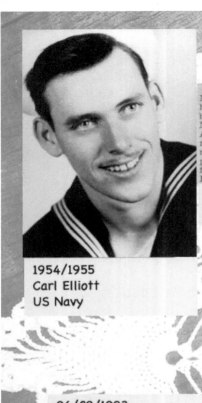

1954/1955
Carl Elliott
US Navy

Carl A. Elliott, son of Mrs. Marie P. Elliott of 23 Spruce street has been promoted to aviation boatswain's mate third class, U.S. Navy, while serving aboard the Atlantic Fleet attack aircraft carrier USS Ticonderoga. The promotion followed successful completion of a Navy-wide petty officer examination conducted in February.

1952
Carl Elliott

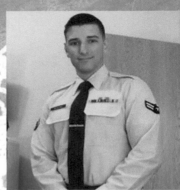

11/24/2019
Dominic Menzone
US Airforce

06/29/1993
Eugenie (Morin) Cadotte
Third Order of Carmel

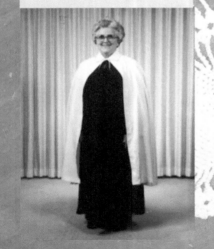

1944
Anthony Menzone
US Navy

here I am again trying to look good for the Pearest family in the world to daddy I love you all. and you to mama. how about a little kiss honey. oh oh and that to ok sweet heart. here I am all for you, my Pear

1945
Anthony Menzone

140

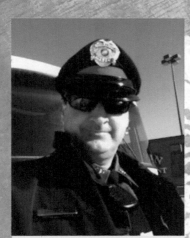

02/28/2011
Daniel Menzone
Sturbridge Police

05/1997
Melissa Menzone
Emergency Medical Tech.

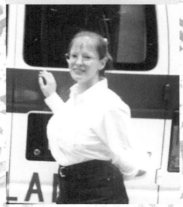

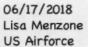

1946
Raymond Elliott
National Guard

06/17/2018
Lisa Menzone
US Airforce

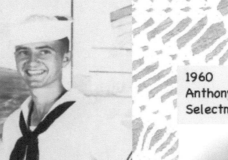

1950
Joseph Menzone
US Navy

1960
Anthony Menzone
Selectman

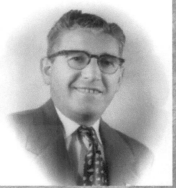

141

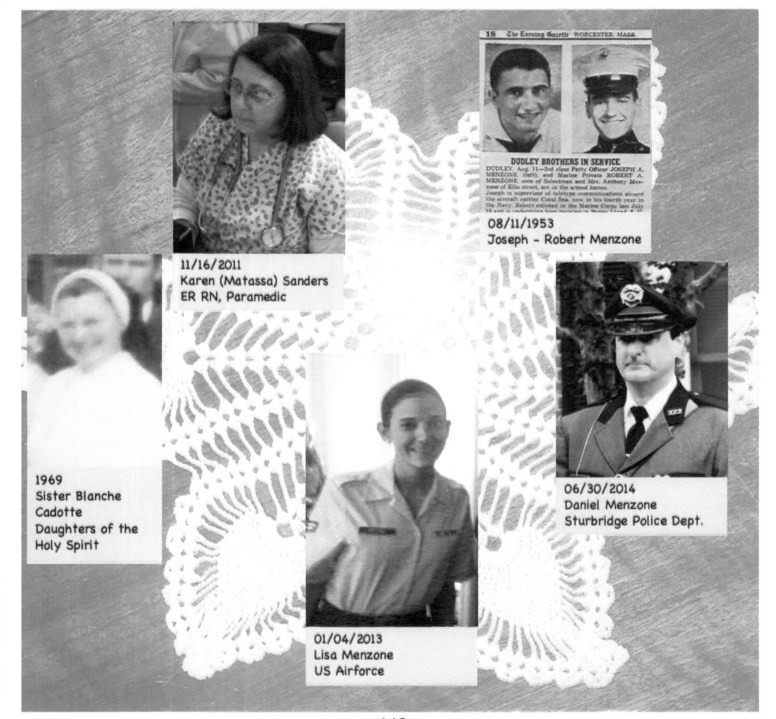

11/16/2011
Karen (Matassa) Sanders
ER RN, Paramedic

18 The Evening Gazette WORCESTER, MASS.

DUDLEY BROTHERS IN SERVICE
DUDLEY, Aug. 11—3rd class Petty Officer JOSEPH A. MENZONE, (left), and Marine Private ROBERT A. MENZONE, sons of Selectman and Mrs. Anthony Menzone of Ellis street, are in the armed forces. Joseph is supervisor of teletype communications aboard the aircraft carrier Coral Sea, now in his fourth year in the Navy. Robert enlisted in the Marine Corps last July 18 and is undergoing boot training in Parris Island, S.C.

08/11/1953
Joseph - Robert Menzone

1969
Sister Blanche
Cadotte
Daughters of the
Holy Spirit

01/04/2013
Lisa Menzone
US Airforce

06/30/2014
Daniel Menzone
Sturbridge Police Dept.

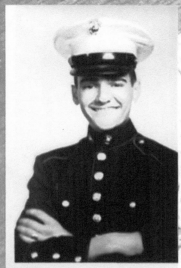

1952
Robert Menzone
US Marines

08/2019
Recognized by the Town of Charlton and the State of Massachussetts in dedication to their US Military service, The bridge is located in Charlton, MA.

FRANCIS HYLKA, SR. JOSEPH MENZONE

MEMORIAL BRIDGE

07/01/2010
Sister Blanche Cadotte
Daughters of the Holy Spirit

05/1997
Daniel Menzone
Emergency Medical Technician

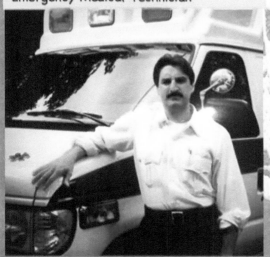

Fills Vacancy

Joseph Menzone Named To Dudley Sewer Board

1970
Joseph Menzone
Sewer Commissioner

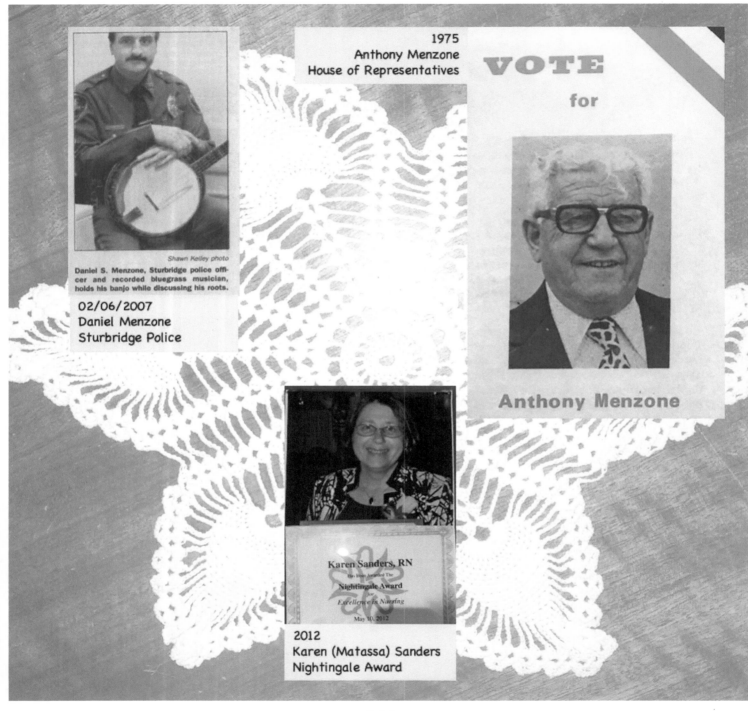

Shawn Kelley photo

Daniel S. Menzone, Sturbridge police officer and recorded bluegrass musician, holds his banjo while discussing his roots.

02/06/2007
Daniel Menzone
Sturbridge Police

1975
Anthony Menzone
House of Representatives

VOTE

for

Anthony Menzone

2012
Karen (Matassa) Sanders
Nightingale Award

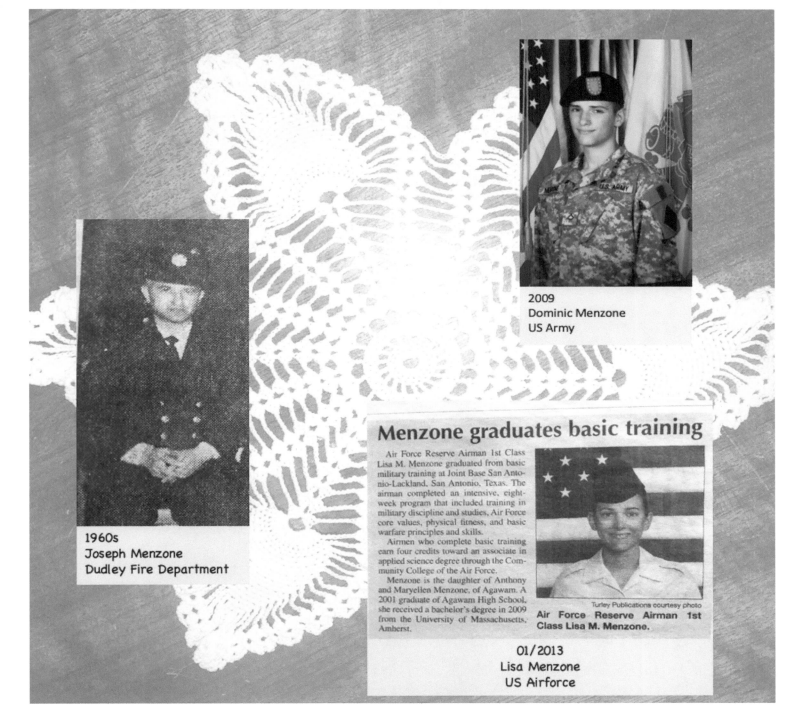

2009
Dominic Menzone
US Army

1960s
Joseph Menzone
Dudley Fire Department

Menzone graduates basic training

Air Force Reserve Airman 1st Class Lisa M. Menzone graduated from basic military training at Joint Base San Antonio-Lackland, San Antonio, Texas. The airman completed an intensive, eight-week program that included training in military discipline and studies, Air Force core values, physical fitness, and basic warfare principles and skills.

Airmen who complete basic training earn four credits toward an associate in applied science degree through the Community College of the Air Force.

Menzone is the daughter of Anthony and Maryellen Menzone, of Agawam. A 2001 graduate of Agawam High School, she received a bachelor's degree in 2009 from the University of Massachusetts, Amherst.

Turley Publications courtesy photo
Air Force Reserve Airman 1st Class Lisa M. Menzone.

01/2013
Lisa Menzone
US Airforce

145

Frank got a job at Pratt & Witney's. He's getting $1660 to start with only he's going to work on the night shift. He also bought a "41" Chevy. I'll say hi to him for you.

174 Farmington Ave.
Hartford, Conn.
Dec. 15, 1953

Top Left: Europe Occupation Service Medal, awarded to Joseph Menzone, 1954

Top Right: Letter to Joseph Menzone from Arline Auclair

Bottom: 02/26/1956 Letter to Evelyn Menzone from Carl Elliott

when you see mom tell her I'm fine & hope they are all the same. I'll write home whenever I get a chance. And are it in I had to write jim a letter. well anyways I'll write soon. well jim I know this letter is short and I can't think of anything else to say. so I'll close for now.

Your Brother
Carl

Things of Note

Dean Martin

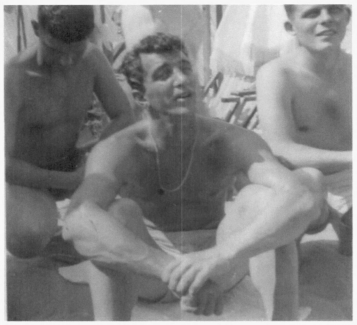

1952

While Dad (Joseph Menzone) served the US Navy on the USS Coral Sea, the aircraft carrier had docked in Italy. Allowed leave, Dad and some friends went to the beach. While there, they bumped into Dean Martin, casually enjoying the sand and sun.

Patrick Wayne

09/24/2011
Patrick Wayne - Melissa Menzone

I had never seen a John Wayne movie until 1987, while I was in college, long after the legend's death, when the local cable TV hosted a month-long movie marathon. I saw Big Jake a dozen times while doing my homework and I became a fan generating a fair collection of John Wayne memorabilia. In 2011, by happenstance, I came upon a Heritage Auction's ad for a display of John Wayne's personal artifacts being held in NYC as part of an upcoming auction. Dan and I made the trek to NYC and while viewing the showcases, I mentioned to Dan how rude it was that "that man" is standing in front of the case. Dan took one glance, turned to me, and said: "You do know who that is?" Patrick Wayne is every bit how I imagined John Wayne to be in real life - a warm, honest, down-to-earth man. I was honored to spend time with him!

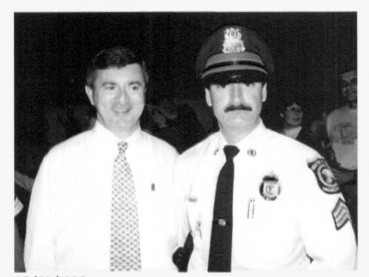

08/20/1998
Governor Paul Celluci

Over the years, Dan Menzone has met hundreds of well-known and influential musicians. I could fill a book of those photos, so I only included a couple here. He worked four years for Webster Police, prior to going to Sturbridge Police. While at Webster, he was awarded Patrolman of the Year and participated in a multi-department sting operation that resulted in hundreds of arrests.

1980s
JD Crowe

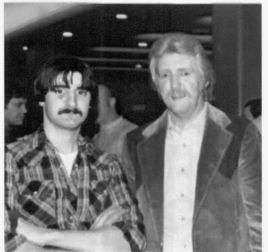

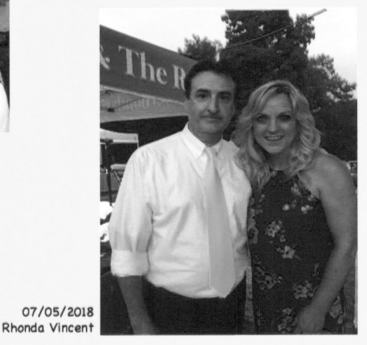

07/05/2018
Rhonda Vincent

05/28/2016
Eddie Adcock

150

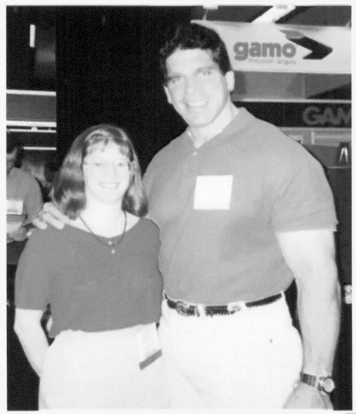

The motto is "What happens in Vegas, stays in Vegas." Except when that happening is meeting legends.

02/1997
Lou Ferrigno
"The Incredible Hulk"

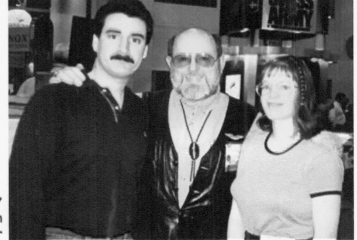

02/1997
Gil Hibben
Master Knifemaker

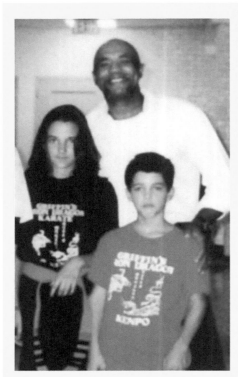

02/1998
Kalaii Kano Griffin
Master Kajukenbo
Lisa - Joseph

06/30/1998
Huk Planas
10th Degree Black
Kenpo Karate
Daniel - Melissa

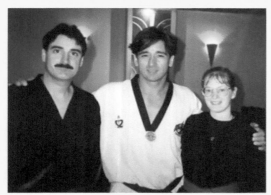

1997
Herb Perez
1992 US Olympian Gold Medalist Taekwondo
Daniel - Melissa

1997
Kathy Long
5-time World
Kickbox Champion
Melissa

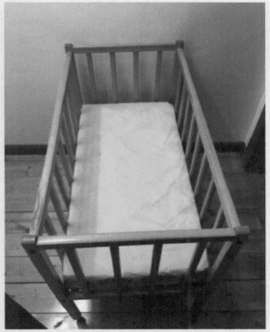

The Treasure Chest

One of four chests from Marie (Morin) Elliott that traveled from Quebec, Canada, to Canaan, Vermont, to Willimantic, Connecticut, and to Dudley, Massachusetts, this chest contained the bulk of the photos accumulated by Evelyn (Elliott) Menzone prompting this writing. Measuring 36"L x 20"W x 24"H, it is wood framed covered with thin sheets of embossed metal and has leather handles on the sides. A second chest is similar in size, just a different embossing, while the other two chests have wood slats on the outside and flat tops.

1900s Chest/Trunk

1960s
Baby Bob sled

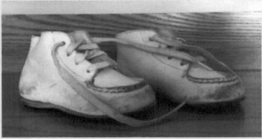

1960s
Baby shoes for Daniel Menzone

1950s Crib
Used by Anthony and Daniel Menzone, pictured on page 82 & 85. It is handmade and would not pass any modern-day safety measures.

1940
Doll belonging to
Evelyn Elliott
Menzone when she
was a child

Her body is a soft
rubber material and
decaying with age. I
gently hold her
together with plastic
wrap. Her head is
sturdier plastic and
in better shape.

The dress and bonnet
are handmade by
Marie Morin Elliott

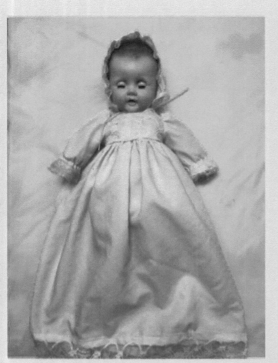

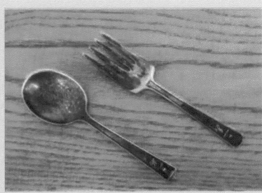

1932
Silver spoon & fork gifted to Joseph
Menzone at baptism. The spoon is
monogrammed "M" and the fork "J"

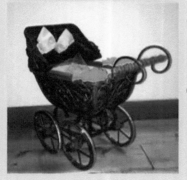

1940s
Doll Carriage from the
Laflamme-Morin family,
pictured on page 12 -
minus the pink and gold
decorations added in
2018.

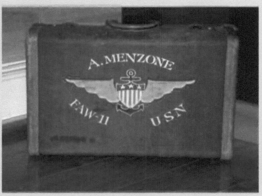

1944
Anthony Menzone's US Navy suitcase
fabric covered with leather handle and
edging. Design is painted onto the fabric.
"Menzone A" is also painted near the
handle and on the reverse.

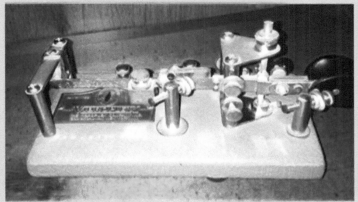

1950s
Vibroplex telegraph for morse code similar to the one used by Joseph Menzone aboard the US Navy aircraft carrier Coral Sea.

1962
Hobby Horse used by Daniel Menzone.
Evelyn claims he would ride it for hours!
Pictured on pages 85, 114, and 122

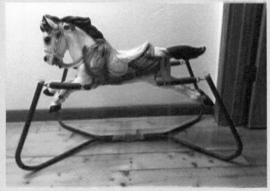

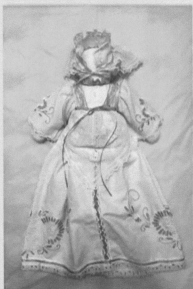

1980s
Memory Doll
A keepsake made in honor of Marie Morin Elliott and given to Evelyn Elliott Menzone by her sister, Shirley Elliott. The doll's dress is a former pillow case embroidered by Marie in the 1940s

1920
Embossed leather bible belonging to Clara Lapreay Menzone. The binding was prefessionally repaired in 2014.

Dear mom dad and Tony

I am siting in my room doing nothing
so I thot I wood right. It is sunday night and thar
is nothing going on. Mr abbertony said we can not have
food in the room, but I am hiding it in my 8 trak tape
player box. He wont let me woch the rest of Roots. But
I don't care I will get him back some how. maybe you
ar sick and tuerd of hering me say I can't wate to get
out of this place. but it is traw I can't wate.
My roommate did not come back yet so I get the room
to my self for to night. When I come home we will
have to go to that gun shop and see want thay have.
I am going to do some reading now, so see you friday.

your favret sun

Danny

02/07/1977 Letter from Daniel Menzone at boarding school to home

**Now
We Are
Poor**

forever and always,
Love –
Melissa

Acknowledgements:

The background artwork appearing on pages 4, 16, 26, 64 through 71, 76, 80 through 95, 102, and 106 through 114 is courtesy of Joseph Menzone (1932-2012). He was an avid painter during the 1980s and 1990s.

The backgrounds appearing on pages 5, 8, 9, 17, 19 through 21, and 27 through 45 is courtesy of Marie Morin Elliott (1901-1998). These examples of her embroidery come from linen pillow covers, handkerchiefs, and table scarfs sewed during the 1930s and 1940s.

The background appearing on pages 140 through 145 is also courtesy of Marie Morin Elliott and is an example of her handmade lace (tatting). This piece was used as a table doily and is approximately 8" across.

The background artwork appearing on pages 121 through 125 is used courtesy of Silver Pencil Press and Melissa Menzone. These pieces are storyboards from several illustrated children's books.

I acknowledge the many unknown family members and friends who stood behind the cameras taking the photos contained in this book. Without them, we wouldn't have this pictorial history of our family.

Finally, I gratefully thank Evelyn Elliott Menzone and Edith Elliott Baronousky for their time answering my questions about the men and women appearing in these photos.

Previous Page:
1980s Pencil Drawing
Joseph Menzone

Rear Cover Photos:
1965 Anthony - Daniel Menzone
1964 Joseph & Evelyn (Elliott) Menzone
1986 Joseph - Lisa Menzone

Lightning Source UK Ltd.
Milton Keynes UK
UKHW050815120421
381757UK00002B/2